CREATIVE
WATERMEDIA
PAINTING
TECHNIQUES

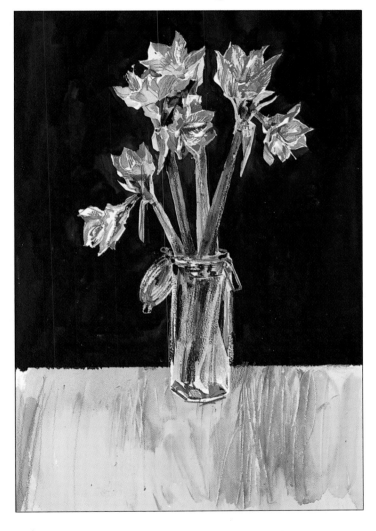

CREATIVE
WATERMEDIA
PAINTING
TECHNIQUES

NORTH LIGHT BOOKS
CINCINNATI, OHIO

Front cover (t): Susan Pontefract, (bl): Paul Apps, (bc):
Stan Smith, (br): Penny Quested; page 1: Stan Smith;
page 3: Richard Smith; page 7: Richard Allen.

Based on *The Art of Drawing and Painting,*
published in the UK by
© Eaglemoss Publications Ltd 1996
All rights reserved

First published in North America
in 1997 by North Light Books,
an imprint of F&W Publications, Inc.
1507 Dana Avenue
Cincinnati, OH 45207
1-800/289-0963

ISBN 0-89134-748-8

Manufactured in Singapore

10 9 8 7 6 5 4 3 2 1

Contents

Part · 1

GET CREATIVE WITH YOUR WATERCOLORS

Using printmaking paper 9

Variegated washes 13

Choosing the right perspective 19

Using sponges for texture 23

Candle and crayon resist 29

Rapidoliner pen and wash 35

Fine lines, delicate washes 41

Self-portraits in watercolor 45

Portraying children in watercolor 53

Painting from a photograph 59

Mixed-media portraits 65

Part · 2

EXPERIMENT WITH UNUSUAL GOUACHE EFFECTS

Mixing water-based media 73

Wash-off with gouache and ink 77

Gouache and gum arabic 83

Using gouache on tinted paper 89

Bringing out the whites 95

Part · 3

ADD EYE-CATCHING INTEREST TO YOUR ACRYLICS

Snow: dealing with white 101

Using a viewfinder: still life 109

Creating texture: rainbow trout 115

Using texture gels 121

Index 127

Part 1

GET CREATIVE WITH YOUR WATERCOLORS

Using printmaking paper

Skies at sunset have always been a favourite theme for painters, and watercolours, with their subtle delicacy and luminosity, help the artist do justice to the soft, glowing light of this magical time.

At sunset the light fades rapidly, so you have to work fast and think on your feet. If you find this too difficult, don't attempt to make a finished painting on site. Instead, make quick watercolour sketches, say, two minutes long each, which capture the light, textures and colours – the essence of the sunset. Take snapshots as extra reference for colours and textures, then use these back in the studio as the basis of a painting.

Our artist chose an unusual painting surface here. He used printmaking paper – an absorbent surface on which the washes diffuse beautifully, creating the slightly hazy effect of early evening light. (If you can't find printing paper, chose an absorbent watercolour paper such as Arches.)

Unusually, too, the artist rejected white paper in favour of a pale grey surface which provides a unifying warm tone. Even without the light-reflecting qualities of a white ground and with a limited palette of five colours, the painting captures the glow of the sky, thanks to the artist's skill in handling paints. Notice how most of the tones are subdued, so that the open sky in the middle appears to glow by comparison.

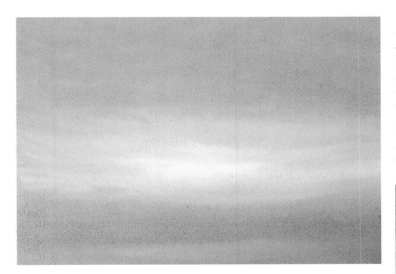

◀1 Dampen the paper, then use your No.20 round to sweep a pale aureolin wash across the sunset, then a phthalo blue wash across the upper sky, allowing the edges of the washes to fuse. Add streaks of white near the horizon to suggest the hazy sun. Add cadmium orange to the yellow wash to block in the landscape.

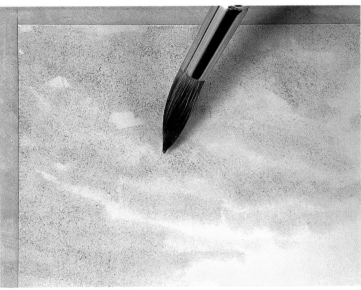

▶2 Start to paint the clouds using a slightly stronger wash of phthalo blue. Use a 'tickling' motion with your brush to simulate the pattern of the clouds in a mackerel sky. Work your brush in different directions, following the way the clouds sweep upward and outward from the middle of the sky. Give the sky a sense of perspective by making the clouds larger in the foreground and increasingly smaller and flatter as they recede towards the horizon.

YOU WILL NEED

- [] A 9⅜ x 13in sheet of pale grey printing paper
- [] Four brushes: Nos. 1, 3 and 20 rounds and a 44mm hake brush
- [] Four watercolours: aureolin, cadmium orange, phthalo blue and Vandyke brown
- [] Titanium white gouache

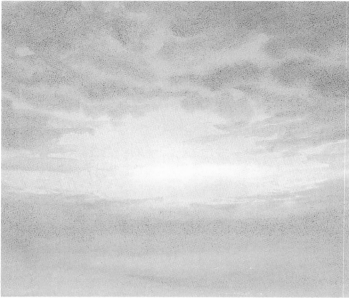

◀ **3** To increase the sense of perspective, deepen the tone of the closer clouds at the top of the composition by adding a touch of cadmium orange to your phthalo blue wash. Similarly, soften and lighten the tone of the distant clouds by adding a hint of white gouache to the blue wash. Keep it subtle, though: too sharp a jump between tones will destroy the impression of soft, hazy light.

◀ **4** Now work on the palest part of the sky, where the sun's light catches the misty clouds around it. Suggest these clouds with very thin, pale washes of white gouache, feathering the edges so that they blend naturally into the surrounding atmosphere. Use the tip of the brush to jot in a few tiny wisps of cloud higher up. Leave the painting to dry so these colours become 'fixed'.

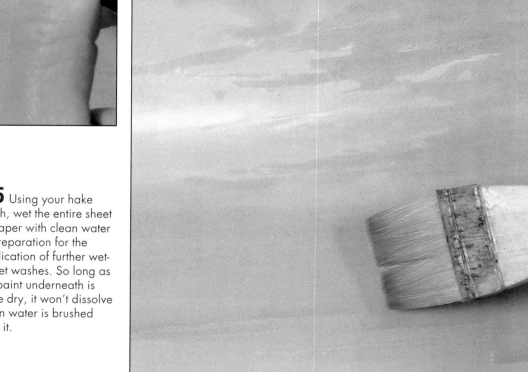

▶ **5** Using your hake brush, wet the entire sheet of paper with clean water in preparation for the application of further wet-in-wet washes. So long as the paint underneath is bone dry, it won't dissolve when water is brushed over it.

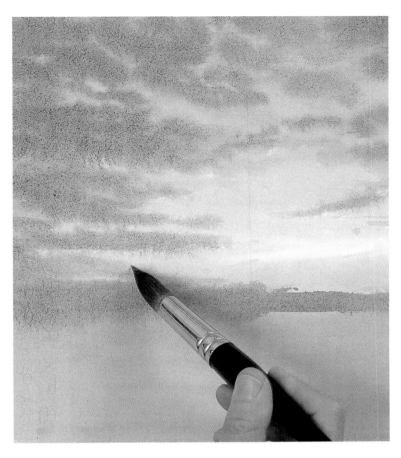

◄ 6 Strengthen the patterns of the clouds – particularly on the outer edges of the picture. To create the texture of the small, puffy clouds, skim your No.20 brush lightly over the paper, leaving plenty of space between the strokes to allow the paint to spread softly on the wet paper while still providing glimpses of the lighter sky between the clouds.

You can see the effectiveness of the wet-in-wet technique in conveying the texture and pattern of the clouds. Notice, too, how luminous the sky appears at the sunset now that the deeper tones have been added. Mix a thin wash of Vandyke brown with a touch of phthalo blue and use this to suggest the hazy landscape in the distance. Leave the painting to dry slightly.

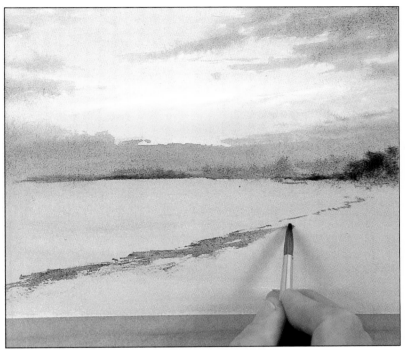

► 7 Strengthen the last wash with more phthalo blue to suggest the line of the distant river bank and trees. Use your No.3 round brush for this. Now tilt the quantities of the wash to more brown than blue to sketch in the foreground shoreline, this time keeping the brush fairly dry and using just the tip to sweep in some ragged drybrush strokes.

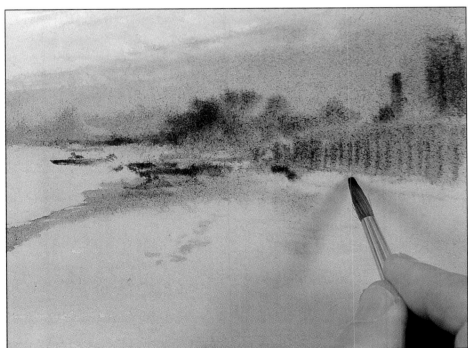

◄ 8 Continue building up the details on the river bank – the muddy shore, the promenade and buildings on the right, and a few boats moored in the shallows. Don't overstate these details but merely suggest them with a few quick dashes and strokes, applied wet-in-wet; remember, they are some way in the distance and the semi-twilight envelopes everything in a misty haze.

9 Suggest the bank of trees on the left side of the river with a pale wash of grey from your palette. Work further washes loosely over the foreshore on the right, leaving patches of the lighter undercolour showing through to suggest light reflecting off the wet mud (see step 10). If you've pitched your tones correctly, becoming paler as they near the horizon, you should achieve a convincing sense of depth and distance. Use your No.1 brush and a dark mix of phthalo blue and Vandyke brown to suggest the masts and rigging on the boats.

As the sun sinks its silvery light catches the undersides of the clouds, so add a few subtle hints of thinly diluted white gouache along the base of the clouds above the setting sun.

10 Paint the reflection of the band of trees on the left of the picture with a very pale grey, leaving a narrow strip of paler tone between it and the trees to suggest the river bank. Break up the broad expanse of the foreshore by adding just a few more spots of colour and texture. Finally, use a pale mix of aureolin and white to suggest the light on a boat and its reflection in the wet mud.

The final picture conveys the quality of the light as the sun sets, warming up the central horizon with a gently glowing orange-yellow. The artist has captured the pattern of the clouds very effectively. Notice how the break in the clouds in the middle of the composition focuses our attention on the sunset.

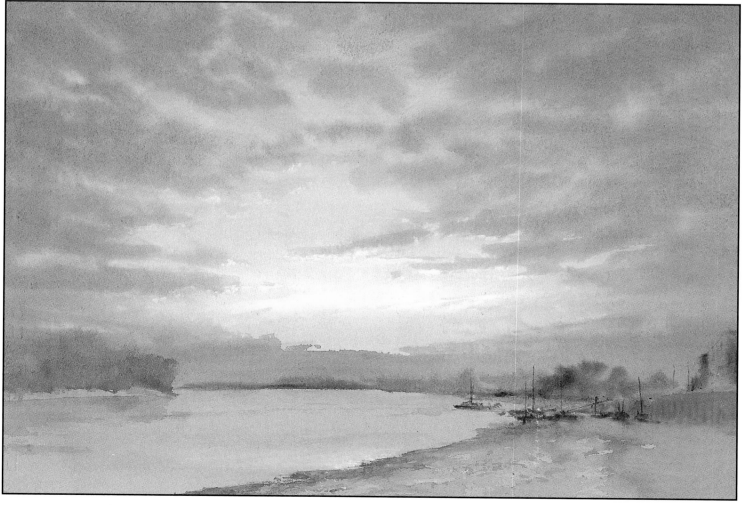

Variegated washes

With variegated washes almost anything could happen in the next half hour. It's simple and fun – find out how.

Variegated washes produce some of the most exciting – and unpredictable – effects in watercolour. The technique is simple, but it requires quick, confident work and you must avoid the temptation to fiddle. If you overwork the washes you risk losing the spontaneous, fresh look which typifies the technique. All you do is dampen the paper, then lay on fairly wet washes in quick succession. Some flare out or burst into neighbouring colours, others produce dramatic branches or rainbows. In addition, there is the excitement of seeing how the paints behave when applied in these loose washes. Certain colours, such as the blues, granulate while others, such as raw sienna, produce even, flat areas of colour.

Applying a variegated wash

▲**1** Protect the areas you wish to save with masking fluid – here the moon. Once dry, cover the picture with water mixed with a drop of oxgall. When the paper surface turns from a shine to a sheen, flood in the first wash.

▲**2** Unless the weather is very hot you have about 15 minutes to complete the picture before the paper dries out too much (in hot weather, the time scale is even shorter!). Drop in another colour and watch how the colours merge.

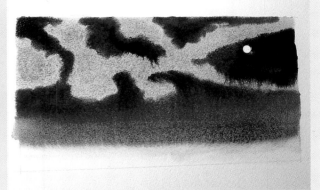

▲**3** Now try applying a third colour in swirls and islands, leaving gaps between several of the new colour areas. Watch to see how and where the new colour areas bleed in towards each other.

▲**4** Apply a fourth colour to the bottom of the picture to create the landscape in your moonlit scene. The picture may continue to change as the colours flare into each other until the paper dries.

YOU WILL NEED

- ☐ A 32 x 18cm (12½ x 7in) sheet of 140lb NOT watercolour paper stretched on to a board
- ☐ Two brushes: a large wash or Chinese brush and a No.6 round
- ☐ A jar of oxgall
- ☐ A ruler and HB pencil
- ☐ Jars of clean water
- ☐ Six watercolours: raw sienna, crimson lake, cadmium scarlet, Winsor blue, Prussian green, burnt sienna

Stormy sky

This technique is best for uncomplicated subjects which don't need much detail. Alternatively, use it for specific areas of a picture – for the sky, say, or the misty distance – and use other techniques where you want more control – on buildings or people in the foreground, for instance.

To encourage the paper to absorb the washes and to help them spread more readily, start by washing water mixed with a drop of oxgall over the picture. The paper looks shiny at first, but once it turns to an eggshell sheen, it's time to start applying the washes.

◀1 Outline the picture area with pencil and ruler. Mix a drop of oxgall into a jar of water and then brush this evenly over the paper with the wash brush. This helps the water disperse evenly and reduces the surface tension so it sinks into the paper more readily.
 Wait for the paper to take on an eggshell sheen then mix a strong wash of cadmium scarlet and raw sienna and stroke this across the horizon in the centre of the picture.

◀2 Now mix a wash of Winsor blue warmed with some cadmium scarlet and a little crimson lake and apply this to the sky with your wash brush. Stroke in extra colour to suggest cloud formations.
 Squeeze the brush between your fingers to remove the liquid, then stroke the edge where the two colours meet. This softens the divide and prevents the colours bleeding into each other too much.

▶3 Add more Winsor blue to the sky mix and put in the very dark cloud forms. Dry the brush and use it to lift out wet colour for the light forms. (Remember that the colours will dry lighter.)
 Mix Prussian green and Winsor blue and wash this into the middle distance. Again, follow up with a dry brushstroke along the join to prevent the colours bleeding excessively.

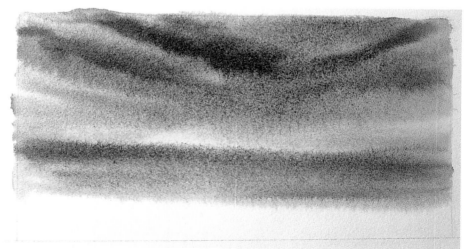

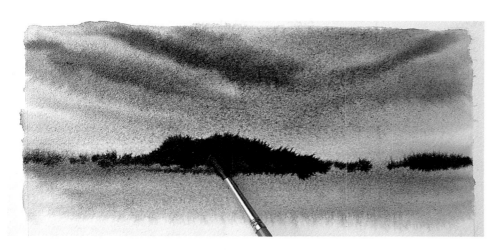

◀**4** For the trees and bushes mix a dark blue-green – a stronger mix of Prussian green and Winsor blue. Apply it with the No.6 round brush, first drawing a line along the base, then going lightly over the top for the tallest vegetation. Don't apply too much paint or the colour may bleed too far into the sky.

▶**5** Now mix Prussian green with raw sienna and burnt sienna to create a sage green. Brush this over the foreground and middleground to indicate the grass, leaving a little of the blue-green mix still showing near the horizon line.

To help create a sense of recession, add a bit more burnt sienna to the foreground to bring it forward.

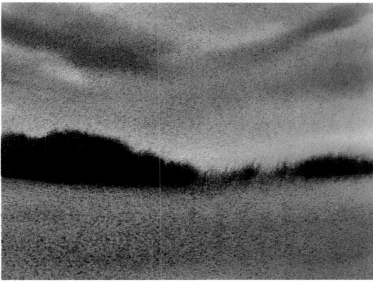

▼**6** In the final picture you can see the interesting effects created by using wet washes side by side. Some colours bleed into each other, making strange shapes or new colours. And notice how the very wet washes give some attractive textures – the Winsor blue in the mixes granulates to create a lovely mottled effect – you can see this in the grass.

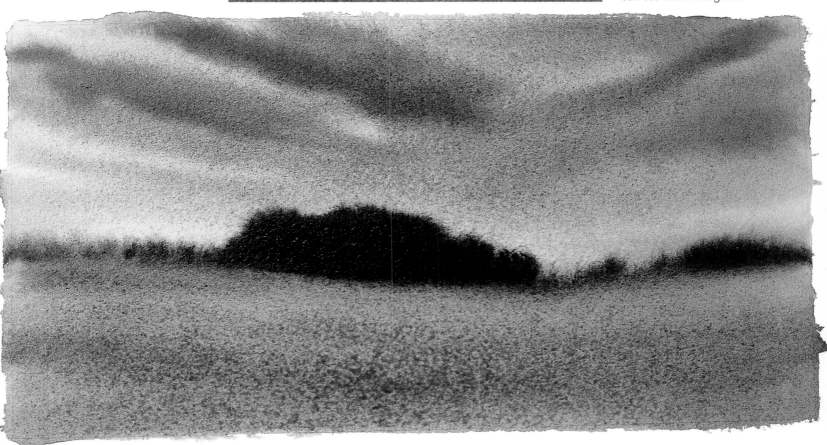

Harvest moon

YOU WILL NEED

- ☐ A 26 x 16cm (10¼ x 6¼in) sheet of 140lb NOT watercolour paper stretched on a board

- ☐ Three brushes: a Chinese brush and Nos.4 and 6 round

- ☐ A ruler; HB pencil

- ☐ A compass (optional)

- ☐ Masking fluid and a small, old brush

- ☐ Jars of water; oxgall

- ☐ Five watercolours: Indian yellow, raw sienna, cadmium scarlet, French ultramarine and Prussian green

- ☐ White gouache

Variegated washes are very unpredictable – which is all part of the fun – but you can control the washes to a certain extent by reducing the amount of paint you apply with the brush. It's also a good idea to keep a dry brush handy so you can quickly remove excess paint or blend two colours together softly. However, don't expect to be able to manipulate the paint too much – that's not the point of the exercise.

The idea is to allow the washes to spread spontaneously over the picture surface, so if you wish to leave a particular area white, such as the moon in this picture, you need to apply masking fluid before you begin. For larger areas an outline of masking fluid should be quite enough.

▶ **The set-up** Our artist referred to his sketchbook for his composition, choosing the first sketch on this page to work from. You could make similar quick sketches to provide the references for your painting, or you could copy one of the sketches here. Alternatively, make up a fantasy landscape from a compilation of landscape scenes.

◀ **1** Draw your picture area on the paper with the pencil and ruler. Draw in the moon – our artist used a compass for this – then paint over it with masking fluid and leave to dry.

Mix a drop of oxgall into some water and brush it over the paper with the wash brush. Once the paper has an eggshell sheen, mix cadmium scarlet with white gouache and paint around the moon and along the horizon with the No.6 brush.

▶ **2** With the same brush mix French ultramarine and white gouache then paint in the sky, leaving a pink halo around the moon and a pink line on the horizon – leave a fairly wide border at first because the paint will spread. Add more blue to the mix and darken the top of the sky – aim to create a graduated blend from top to bottom to suggest recession.

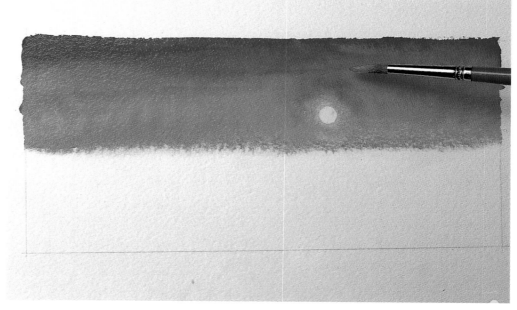

▶ **3** Mix a thin green wash of raw sienna, Prussian green and cadmium scarlet, then paint the foreground with the Chinese brush. Notice that our artist's wash blended into the blue of the sky, covering over the pink horizon line completely. This didn't matter because the green created some interesting grassy marks as it bled into the sky.

Add more raw sienna and some Indian yellow into the green mix and go over the foreground grassy area.

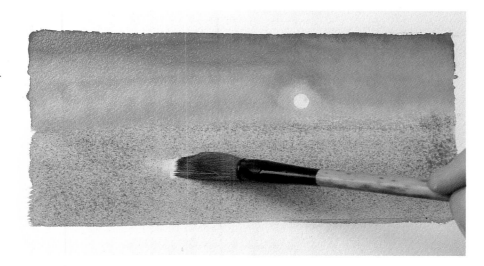

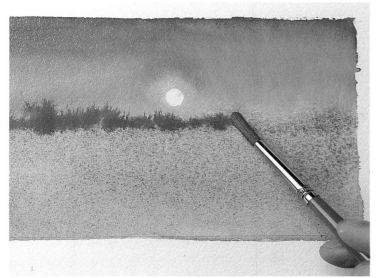

◀ **4** For the line of trees on the horizon our artist mixed Prussian green into the sky mix and applied the paint with the No.6 brush. Sometimes he allowed it to flare into the sky and in some places he went over the top edge of the colour with a dry brush to prevent too much bleeding.

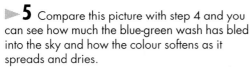

▶ **5** Compare this picture with step 4 and you can see how much the blue-green wash has bled into the sky and how the colour softens as it spreads and dries.

Use your strongest grass mix to go over the foreground again to enrich the colour here.

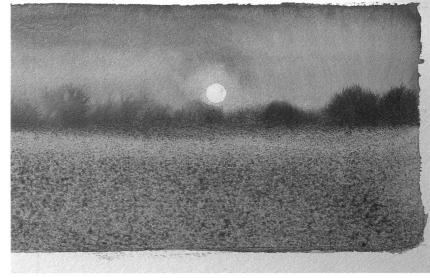

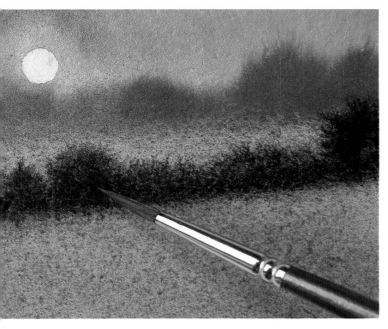

◀ **6** The colours of the hedges and trees should become stronger and warmer as they come forward in accordance with the rules of aerial perspective. So for the next line of bushes our artist used a mix of Prussian green and cadmium scarlet, applying the colour with the No.4 round.

▶ 7 Paint the darkest hedgerow in the foreground with a thick mix of Prussian green. Drag a wash of cadmium scarlet over the front field and blend it in with a dry brush. Then dot some red into the bushes – this warm colour helps to make the foreground advance still further. Leave the picture to dry.

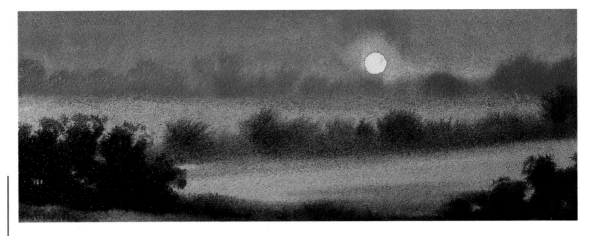

▶ 8 Once the picture is well and truly dry, rub off the masking fluid. Then use the No.4 brush to paint in the moon with a very pale mix of white gouache and cadmium scarlet. Gently dot some very pale blue markings (white and French ultramarine) on the moon to suggest the undulations on its surface.

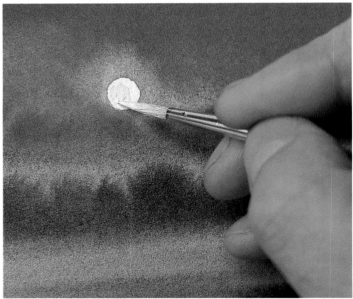

▼ 9 The finished picture perfectly describes a country landscape seen at twilight with a light mist in the air. The harvest moon, warm and low, casts a glowing light which barely cuts through the mist.

Even if you've used the same composition, your picture will probably look quite different. It's part of the fun of variegated washes that you never know quite what effects you will end with.

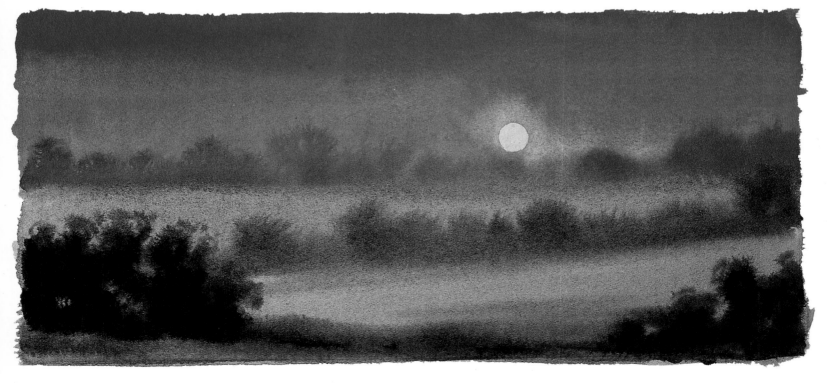

Choosing the right perspective

Always keep a look out for views with dramatic or unusual perspectives – these will make your compositions more exciting and catch the attention of the viewer.

Large rivers provide a wide vista with plenty of sky, and there's often a lot going on, though at a leisurely pace. Our artist took a stroll along the river, making sketches and taking photographs as references for paintings. He made several thumbnail sketches before deciding on this composition.

By sitting astride the river wall, our artist made himself comfortable and found he had an excellent viewpoint. The river divides the scene into thirds while the wall and lamp post lead the viewer in and break the horizontal divisions. To ensure the scene appears to recede towards the horizon he has made the foreground lively and textured and the background softer.

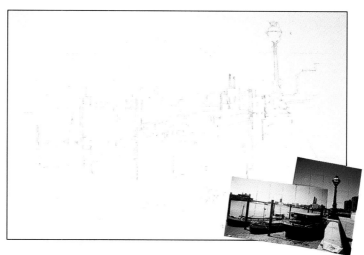

1 Use your photos and sketches as references to draw in the composition. Our artist gridded up his photos to help him place each feature accurately.

2 Scribble candle wax over the foreground to create a resist, then mask out the seagulls, ropes, lamp highlight and other items you wish to keep white.

With the large brush, wash over foreground, wall and pavement with a thin mix of yellow ochre, chrome yellow and light red. Brush water over the sky, then wash on a mix of Winsor blue/cerulean. Add alizarin crimson as you move down to make the sky recede. Apply the blue wash to the river with a dryish brush, then strengthen the top of the sky with more blue.

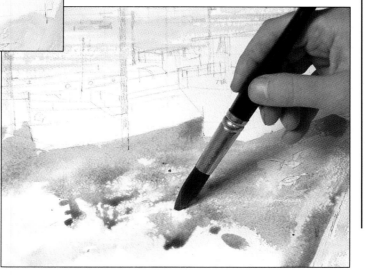

3 Now mix Indian red, Vandyke brown and yellow ochre to strengthen the foreground, using the large wash brush. Also work on the right of the river wall with a thinner version of the same mix. Use the round brush to tidy up any areas that need it.

While the foreground is still wet, dot in some Vandyke brown. The colour will flare out, adding to the effect of the silty river bed.

Tip

Smooth washes
Our artist had a handy trowel-shaped sponge wash brush. Its large, absorbent head made easy work of washing in the

huge expanse of sky, and our artist enjoyed using it, too. If you can't get one, make your own from an old brush and a synthetic sponge.

YOU WILL NEED

☐ *An 18 x 24in sheet of 140lb NOT watercolour paper*

☐ *Drawing board and masking tape*

☐ *Some scrap paper*

☐ *Craft knife; 2B pencil*

☐ *Two jars of water*

☐ *A watercolour palette*

☐ *White wax candle*

☐ *Masking fluid*

☐ *Small brush to apply the masking fluid*

☐ *Four brushes: large nylon wash brush, medium squirrel wash brush (our artist used a No.10), a No.7 round & No.1 rigger*

☐ *Eleven watercolours: chrome yellow, yellow ochre, light red, Indian red, sap green, alizarin crimson, Winsor blue, cerulean blue, Prussian green, Vandyke brown and Payne's gray*

▶ 4 Mask the boats with scrap paper and spatter Vandyke brown over the wet foreground with the large brush. Allow to dry.

Mix some alizarin crimson, Vandyke brown and Payne's gray and use the mix to put in the background buildings, the mooring posts and the boat hulls, changing the proportions of colour in the mix for variation. Use the direction of your brushstrokes to show form, for example, making vertical strokes for the chimneys in the background.

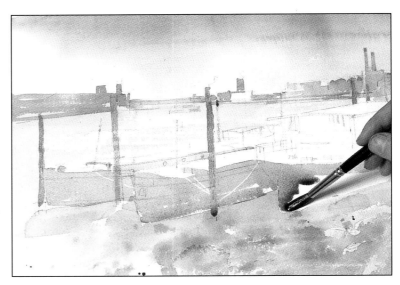

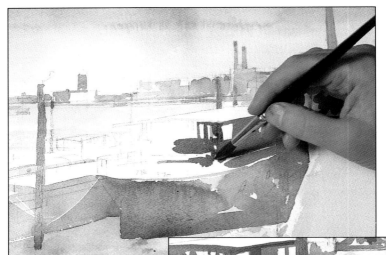

◀ 5 Now use the red/brown/grey mix to put in the lamp post. Add more brown to the mix and dab it on to the sides of the boats with the medium wash brush, letting the colour melt into the first wash to give the boats more form.

Use a strong Payne's gray wash to put in the boat houses, 'drawing' in the fine details with the tip of the brush.

▶ 6 Use the brown-grey mix to darken the mooring posts and put in the shadows by the wall. Allow the brush to become fairly dry as you move towards the foreground. This drybrush texture helps to bring the area forward.

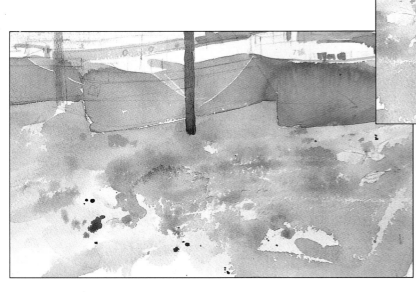

◀ 7 Watercolour appears much lighter when it dries, so check if the colour of the river bed is strong enough. Work on the area if necessary, but don't overdo it. Notice how our artist has left some areas pale, while allowing the paint to puddle in others for greater textural variation.

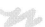

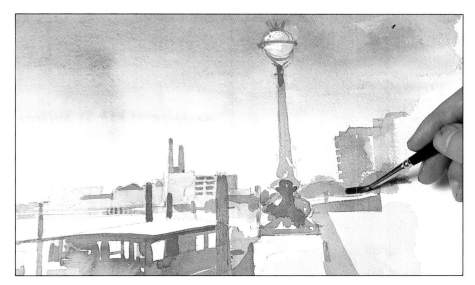

◀8 Keep turning your attention from one area of the painting to another so you bring the whole picture on at the same rate. Move on to the distant buildings. Use several variations of the red/brown/grey mix to put in the windows and shadows with the No.7 round brush.

Darken the chimney in the distance with Vandyke brown and paint the block of flats on the right with some Indian red strengthened with Vandyke brown. Don't simply block in the building as one flat area but use brushstrokes to show form, as our artist did here. Notice how these reddish colours sing out in a mainly blue painting. Put in the trees by the river with a mix of sap green and brown.

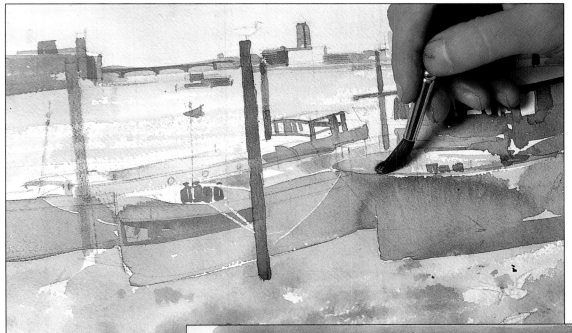

◀9 Now draw attention to the boats with some bright colours. Apply a mix of cerulean blue and Prussian green for the decks of the two boats closest to the water.

Use the medium wash brush and a strong mix of reds to pick out red areas such as the flags, canisters and the deck of the boat nearest the wall. Notice that the red band on the centre boat is dulled by the grey underneath it.

▶10 Use a strong mix of Vandyke brown and Payne's gray to darken the boat hulls, letting the grey underneath show through in places for highlights. (The hull details didn't show in our artist's photographs, so he went back to his sketches to fill in the missing information.)

Use the dark grey mix slightly diluted for the shadows of the mooring posts on the river bed. Then apply a mix of light red, Payne's gray and Vandyke brown for the shadows of the boats. Leave the picture to dry.

11 With the boats strengthened, the foreground looks too pale, so spatter a little sap green on the river bed to enliven it, using scrap paper to protect the boats. Also spatter on some of the dark brown mix and darken the building on the left with the same colour.

12 Use the medium wash brush for the darkest shadows – on the lamp post, boats and mooring posts. Think where you are putting the colour – the idea is to 'sculpt' the three-dimensional form of each item. Keep tonal contrasts greatest in the front.

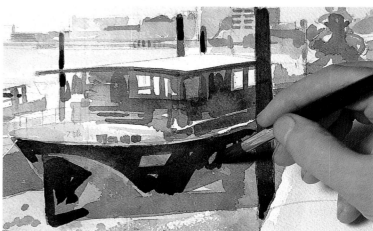

13 Leave the painting to dry, then rub off the masking fluid. Use the rigger for details such as the rigging and the seagulls. If the seagulls look a bit messy, tidy them up once dry by scraping them with a knife. Also use the knife on the deck of the near boat to give texture.

Notice how the river wall leads the viewer into the picture and how the eye is led by the touches of red and brown. The foreground is lively with a high contrast, ensuring this area remains in the forefront.

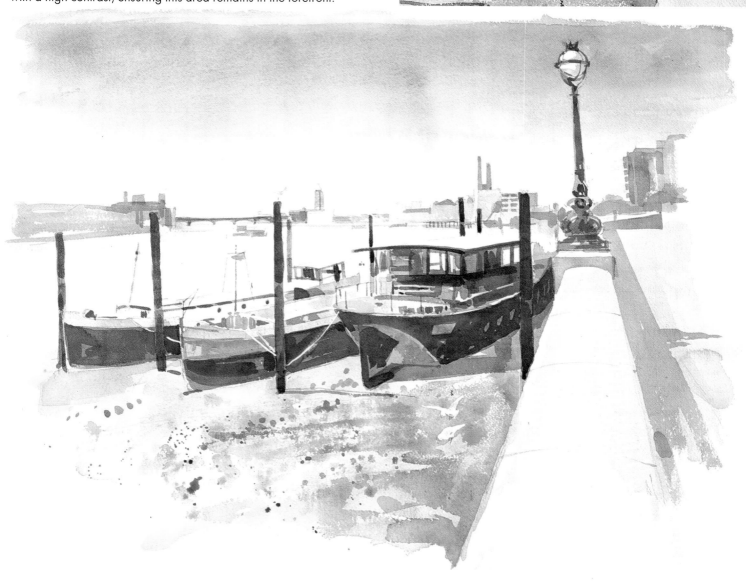

Using sponges for texture

Sponges play a vital role in watercolour painting – not only for dampening large areas, but also for applying washes, lifting off patches of colour and creating texture.

Think of watercolour materials – brushes, papers and pans or tubes of paint immediately come to mind. But artists frequently make use of a whole range of other items – rags, torchons, craft knives and even sponges – all essential additions to their armoury of equipment.

It's fun experimenting with sponges to create many different effects. For instance, you can produce vast washes – flat, graded and variegated – wet-on-dry or wet-in-wet. And dabbing on fairly dry colour produces a wonderful mottled effect, perfect for such textures as tree bark, rough paths and weathered rocks.

Vary your handling of the sponge, pressing hard for big splodgy marks or using a light, tapping motion for an even, stippled effect. If you work on a damp surface, the effect is soft, while on a dry surface, the marks are more defined.

It's a good idea to have both natural and synthetic sponges in a variety of shapes and sizes. Buy large ones, then cut them up into different sizes and shapes to suit yourself.

A variety of sponges

▲ Cut your sponges into many shapes and sizes. This small round sponge is quite dense, so it creates a heavy texture on the paper.

▲ The texture of this sponge is rough and shaggy – it creates loose, interesting textures on the paper.

▲ A synthetic sponge has an even texture which produces a finer mark than the natural type – almost like spattering!

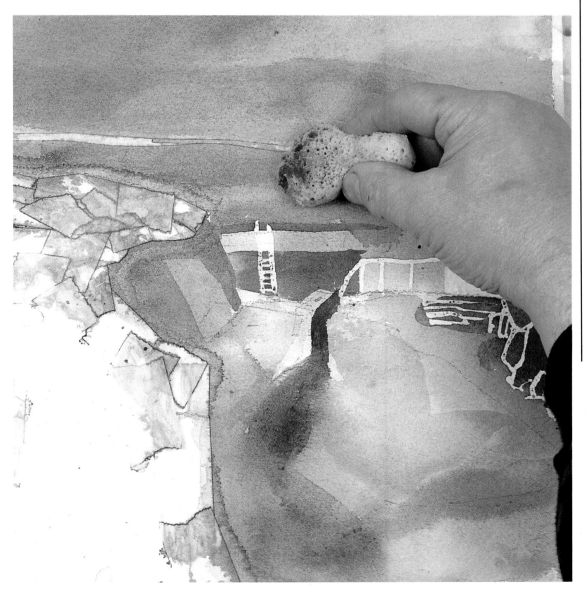

◄ You can use sponges instead of brushes for a wide range of watercolour techniques – laying washes, adding texture or removing colour. In this detail, the artist applies a new tonal layer with a small natural sponge.

The Cobb at Lyme Regis

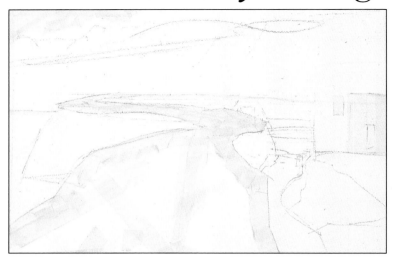

◀ 1 Our artist's composition was taken from a watercolour sketch he made of the Cobb at Lyme Regis in Dorset.

Map out your drawing on the stretched paper. Then use masking tape to mask off the path, boat shed and sky. With the No.6 brush, apply masking fluid to protect the finer details, such as the sea splashing against the lower wall of the Cobb, the ladder, the railings and the grout in the wall. Leave to dry. Clean your brush.

▼ 2 Soak your large natural sponge in clean water and squeeze out the excess. Then use it to wet the surface of the picture, ready for the first wash, working around the masked areas.

▶ 3 Using the same sponge, apply a wash of Payne's gray to the wet paper. Cover the page, including the masked sky, leaving only the path and sandy area.

▶ 4 Don't worry if your initial wash is somewhat flat. You can make areas darker or lighter in tone as you go along. For example, try squeezing water straight on to the page then using your sponge to move it around at random. Let the paint seep under the masking tape – it's part of the fun. Leave it to dry. (To speed up the process, use a hair dryer.)

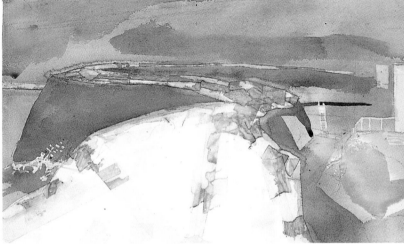

◄ 5 Mix some rich neutral colours with Payne's gray, alizarin crimson and cadmium yellow, and dab them on to the wall of the Cobb with your small natural sponge to create a softly mottled effect.

▼ 6 Mix a variety of blues, greens and golden yellows from combinations of cobalt blue, Hooker's green, raw sienna, alizarin crimson and cadmium yellow, and apply them to the sky, hill, wall and right side of the Cobb. Again, use your natural sponge. Allow the colours to melt into one another to create a variety of tones. Leave to dry.

▼ 7 Using the small natural sponge, again apply rich golden tones to the sand. With a mix of Payne's gray and cobalt blue, add darker tones and textures to the hill by dragging the sponge across the paper and dabbing paint on to produce a slightly mottled effect.

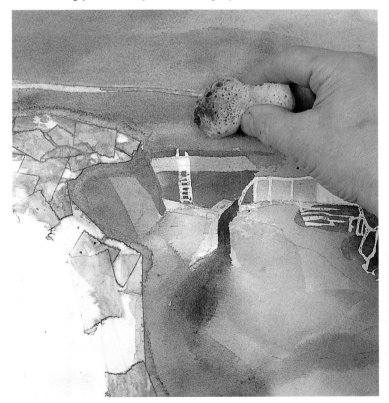

▼ 8 Now sponge in darker tones on the hills, the wall of the Cobb and the cliff tops with the blue and green mixes you made in step 6, squeezing colour on to the paper and working with the sponge wet-in-wet. Allow the painting to dry thoroughly.

Have fun, using overlays of colour wet-in-wet, and adding splodges of paint dropped straight on to the paper. For extra texture, flick and spatter a little paint on to your painting – as our artist did on the lower right area of his painting. Add linear details, such as those on the hills, using the edge of a piece of card covered with paint.

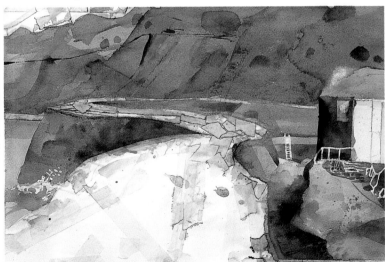

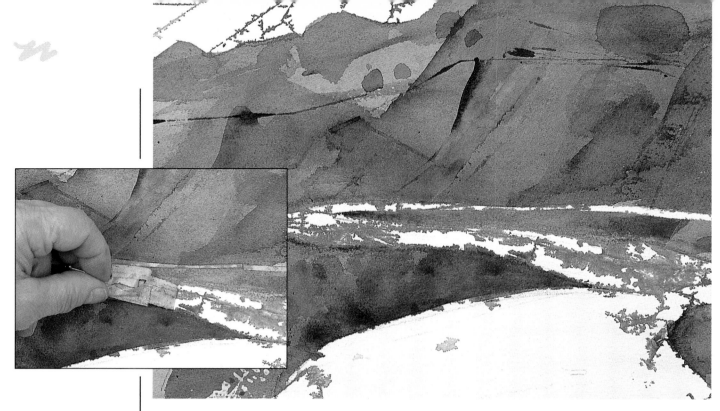

9 Now remove the paper and masking tape (inset above). It's important to lift the tape carefully without tugging it; otherwise you'll tear the paper and ruin your painting.

The Cobb and sky stand out boldly with the mask removed. Paint which seeped underneath the masking tape has produced the jagged lines of colour and texture on the path and sky.

10 Our artist first removed the dried masking fluid by rubbing with his fingers, then added interesting lines and textures with a rolled up piece of card dipped in white gouache. For finer lines, use the edge of a card or even a phone card or an old credit card.

He also toned down the jagged lines on the path by taking the colour back with white gouache paint and the No.12 brush (inset below).

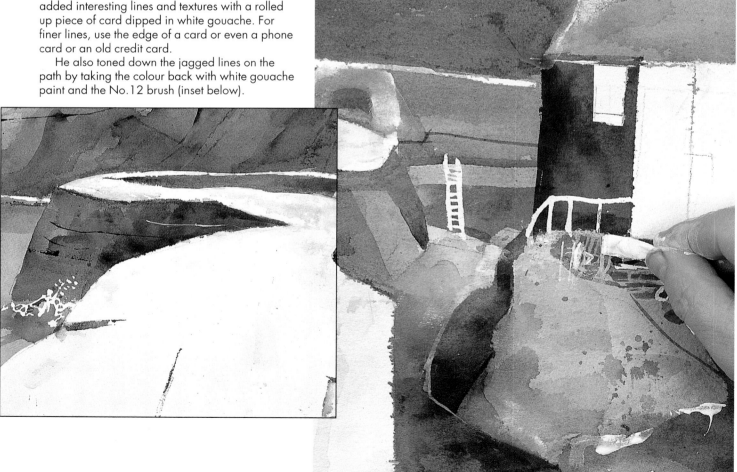

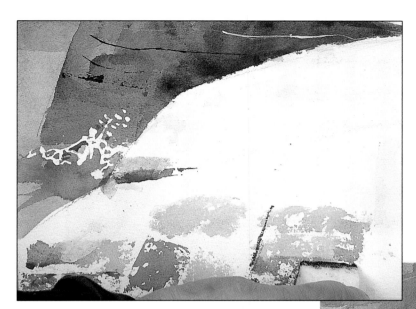

◀ **11** Use synthetic sponges in various sizes to put in the different colours and textures on the stone path. Make use of the greens, ochres and blues you mixed in step 6.

Depending on the tones you wish to print, either dip your sponge into a single colour wash or, for a more mottled effect, select several colours and apply them to the sponge with the No.12 brush.

▼ **12** Scratch in highlights with a craft knife – as seen here – but don't dig into the paper too much, or you'll ruin the paper's surface. Don't overdo the scratching, or the result won't look fresh.

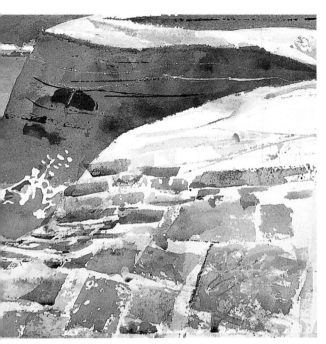

▲ **13** Stand back to assess your work so far, and add any details you think are necessary.

Notice how the squares of colour get smaller as the eye travels into the scene, creating an accurate sense of perspective. The sponge markings also help to offset the flat surface of the path, adding contrast and providing depth.

▶ **14** Use a piece of synthetic sponge, loaded with cadmium yellow, to add linear effects and smudged blobs to the sandy area to create light patches of sand.

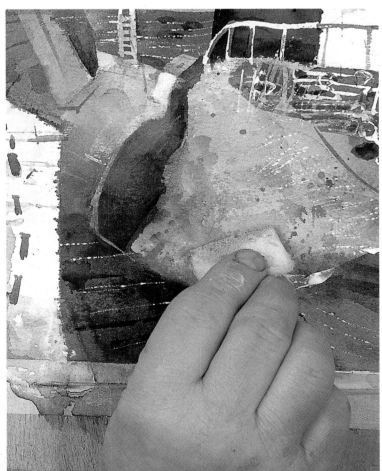

► **15** Working wet-on-dry with small wedges of synthetic sponge allows you to add details to the wall of the Cobb and also lift off colour from it.

Tip

Playing your cards right
Using pieces of card to paint adds freshness to your work because it forces you to act boldly without concentrating too much on detail. Shape your pieces of card so that they're the right size to create the effects you want.

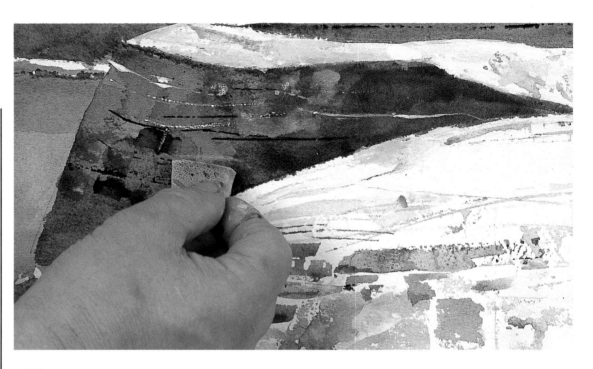

▼ **16** The combination of different sponging techniques creates a freshness and a sense of immediacy in the finished landscape. Notice also how the lighter areas advance and the darker ones recede, resulting in an overall feeling of depth.

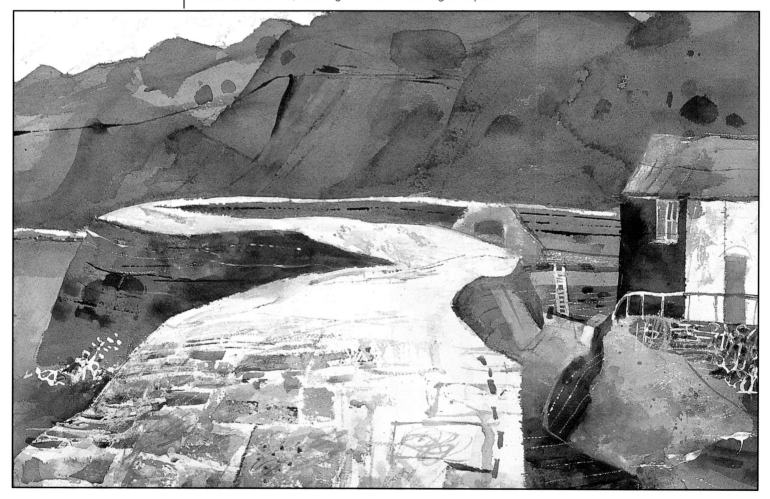

Candle and crayon resist

Wax resist works by masking the paper with an impermeable layer that repels watercolour. It can achieve stunning results.

Wax resist offers an easy and enjoyable means of adding texture to your paintings. The easiest way to apply it is with a candle. You can use a sharpened piece to draw precise lines or the side to mask broad bands. And you can do the same with wax crayons. These bring bold colour and texture to a work; if you apply them lightly on textured paper, you can combine several layers of crayon/watercolour.

Using wax resist needs forward planning – you must have a good idea of what you want to achieve. Once wax has been applied it can be messy to remove, so experiment first.

Here our artist sought to capture the strong lines and energy of amaryllis flowers with a variety of wax resist techniques. On some she used a candle sliver to describe the dramatic white lines on the petals, on others she applied white and orange wax crayons for a slightly different effect. This variation between the candle and the white crayon resists generates an interplay between the blooms and adds energy to the picture. On two flowers our artist simply used a fine brush to paint the delicate structure of the petals, leaving the white of the paper to show through.

◀ **The set-up** Our artist was struck by the bold shape and colour of these amaryllis flowers and decided the white lines on the petals were ideal for wax resist. She chose a plain dark blue cloth for a backdrop to contrast with the brilliant scarlet petals.

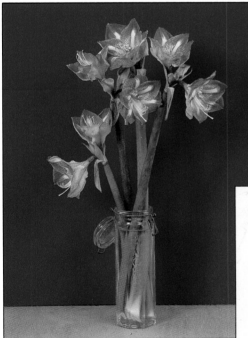

▶ **1** Sketch the subject in bold, yet precise pencil strokes. The background will be painted in last, so leave strong, uncomplicated shapes between the stems.

Use the tip of a sliver of wax candle to detail the white lines on the large flower head (top right). Don't use too much. You will need some white paper in the centre of the blooms for later detail. Use the same sliver for white highlights on the sides of the vase and around the details of the metal catch.

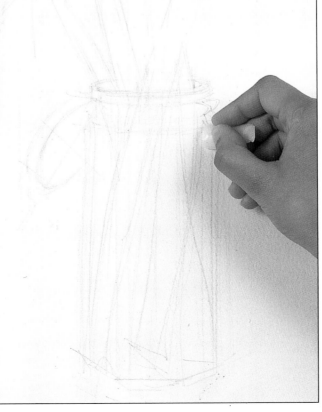

Waxing lyrical

▲ A white wax candle produces strong areas of white resist with smooth edges.

▲ A yellow wax crayon shows up well and can be used to draw strong areas of colour.

▲ Lines from a white crayon have slightly blurred edges when watercolour is applied.

▲ Coloured crayons make bold, coloured water-resistant lines.

YOU WILL NEED

- ☐ *A 22 x 30in sheet of 140lb NOT watercolour paper*
- ☐ *An old toothbrush*
- ☐ *Masking tape*
- ☐ *Palette for mixing*
- ☐ *An HB and a 2B pencil; craft knife*
- ☐ *Three round ox/sable brushes: Nos.6, 9 and 10*
- ☐ *Jars of clean water*
- ☐ *White candle; ruler*
- ☐ *Red, orange, dark green, yellow and white wax crayons*
- ☐ *Twelve watercolours: cadmium yellow, cadmium red, alizarin crimson, rose madder genuine, French ultramarine, cerulean blue, Hooker's green, terre verte, raw sienna, sepia, burnt umber, Payne's gray*
- ☐ *Seven water-soluble coloured pencils: light blue, burnt ochre, scarlet lake, vermilion, dark green, olive green, true green*

▲ **2** Use the yellow crayon to highlight the bases of the flowers on the right, their sepals and petals. Draw a bold line along the stem with a dark green crayon. Don't apply too much pressure, but allow the texture of the paper to show through to pick up the watercolour later.

▼ **3** Use the No.6 brush and cadmium red for the petals. The wax resist instantly repels the watercolour and leaves clear white and yellow lines. Apply free brushstrokes to vary the intensity of the red for each petal. Wait for the paint to dry and then paint in delicate highlights in rose madder genuine.

Apply a light wash of terre verte on the sepals and base of some flowers and a slightly darker version for the thick stems, but don't continue this into the vase. Use neat Hooker's green on the darker stems near the flower heads.

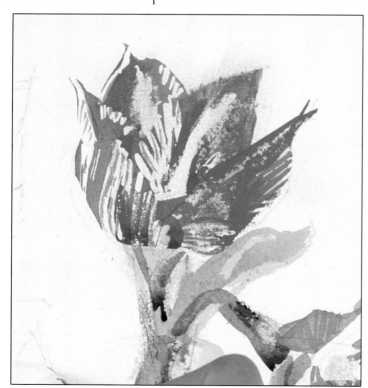

▲ **4** Now turn your attention to the flower in the centre of the picture. Use the white crayon to draw the lines on the petals.

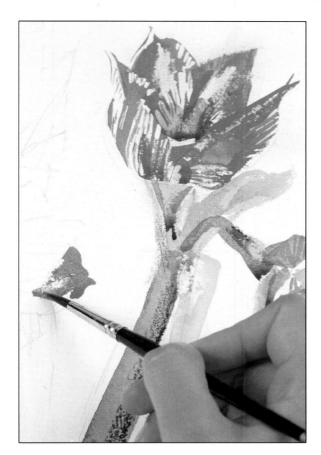

◀ **5** Mix Payne's gray and Hooker's green and paint a dark shadow in the heart of the flower on the top right. Add a patch of Hooker's green and a little raw sienna to the petal on the right.

Now paint in the petals over the white wax crayon resist on the centre flower. Use a variety of reds for the petal shapes to emphasize the three-dimensional quality of the flower. Use cadmium red for the strongest washes, but vary this with mixes of alizarin crimson and rose madder genuine.

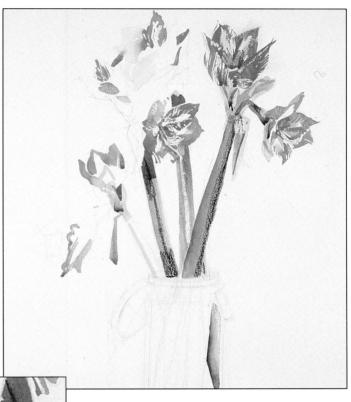

▶ **6** Paint over each flower in turn, using a variety of resist techniques first. Don't go into too much detail at this stage. Use a little of the orange wax crayon on one of the petals for more variation.

Mix a variety of greens and yellows and use these to give more form to the stems and sepals. Add a bar of cerulean blue along the right side of the vase. Wait for these washes to dry, then assess the impact of the painting so far.

◀ **7** Draw strong outlines on some petals with a red wax crayon. This adds diversity and creates more interest. Use your red mixes to add detail to the flowers. Stay with the No.6 round brush to paint some of the flowers with no wax resist.

▶ **8** Draw the underwater stems in a much freer and more vigorous style with the dark green and yellow wax crayons. Overlay these colours in places to emphasize the distortion caused by the glass vase. Leave some white paper here so you can flood in a watercolour wash later. Use the yellow crayon to pick out some highlights on the rim of the vase.

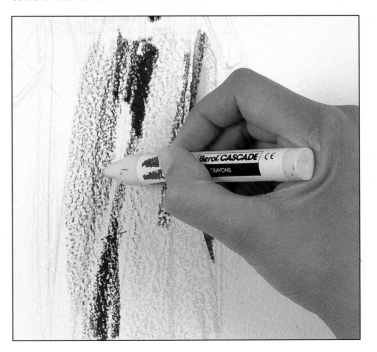

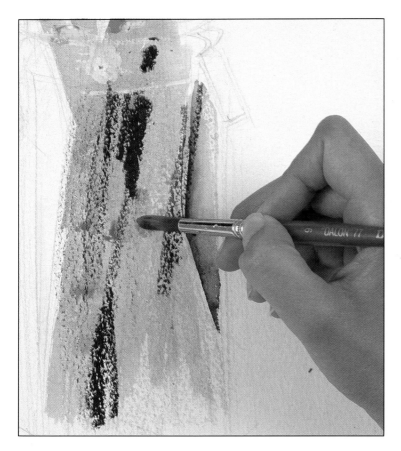

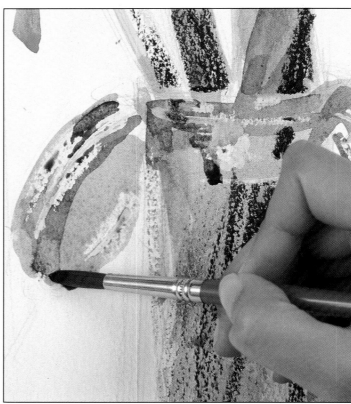

▲**9** Mix Hooker's green with a little cerulean blue and sepia and wash over the waxed stems using the No.9 brush. This is the biggest area of wax resist and creates quite a different texture to the more controlled area of the petals.

▲**10** Apply a few touches of Payne's gray to the tallest bloom. While these are still wet, drop in a dot of cadmium yellow. Work through the flowers, adding some darker lines and touches to their structures. This contrast brings forward the reds in the petals.

Apply candle wax and a line of white crayon to the lid of the vase. Wash dilute cerulean blue/Payne's gray over the lid. Darken this colour with more Payne's gray to describe the lid's edge.

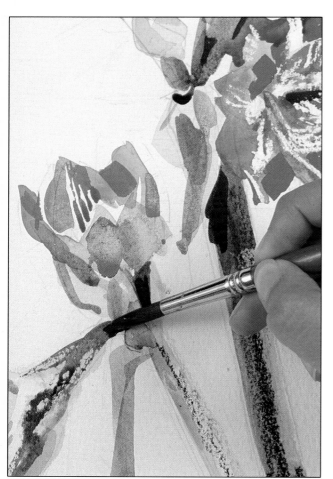

◄**11** Use an array of reds and delicate oranges to build and finalize the shapes of the flowers. Paint in the darker flower stems with a strong mix of Hooker's green. Apply the paint directly over the yellow wax crayon at the base of the flowers. This causes the paint to form droplets over the wax and to dry with an attractive and unusual speckled texture.

►**12** Use the scarlet coloured pencil to draw in the stamens in the centre of some of the flowers. If you have applied a lot of wax to these areas and are finding it difficult to make a mark, dip the tip of the pencil in water to produce a clearer line.

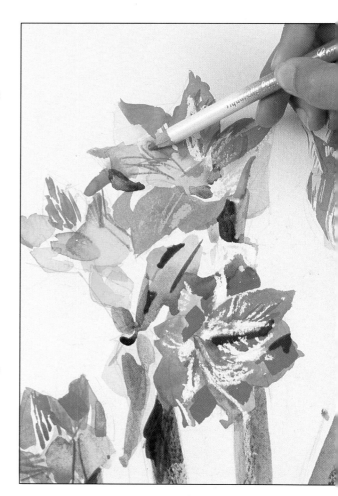

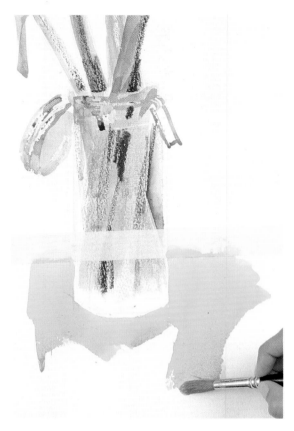

◀ **13** Mark the division between the blue backcloth and the table with masking tape. Make sure this is applied horizontally, but not too firmly. Allow some gaps for the paint to bleed through – too perfect a line will distract the viewer's eye from the flowers. Use the No.10 brush to paint around the base of the vase with a strong wash of raw sienna. Use bold, uneven strokes to fill the area loosely.

▶ **14** Use an old toothbrush to apply a thick wash of burnt umber to the right side of the table. This technique enhances the work's texture and helps to imply wood grain.

▼ **15** Before the burnt umber has had a chance to dry completely, scratch the surface of the paint with your nails or a wide-toothed comb to add more energy to the foreground. Mix cerulean blue with a touch of Payne's gray and use this to paint the reflections of the backdrop at the bottom of the vase.

◀ **16** Allow the colours on the table to dry completely before removing the masking tape. Turn the board upside-down and apply a fresh strip of masking tape. Use a very strong mix of French ultramarine to block in the background. Leave a white outline around some of the flowers to help separate them from the background. Paint several layers of French ultramarine to build up the intensity, but leave the coverage rather uneven.

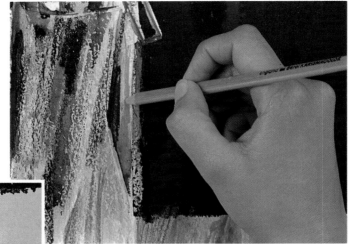

17 When the background is dry, turn the picture right way up and assess the impact. The flowers should now look vibrant and strong. Use the light blue pencil to fill the spaces of white inside and on the bottom of the vase. Draw a small area of shadow on the right of the vase with the soft 2B pencil and go over this with the blue pencil. Also use the 2B pencil to draw the edges of any stems which may have lost their definition.

18 Use the burnt ochre coloured pencil to draw some vigorous lines on the left of the table. Mix a watery wash of sepia and brush this over the burnt ochre pencil lines – this lifts the pencil marks and blurs them into the surrounding area. Apply a similar wash to fill any unwanted areas of white paper remaining on the table.

Use the selection of coloured pencils throughout the picture wherever more detail is needed, but don't overwork the picture.

19 A vase of flowers is a deceptive subject to paint. It may appear simple, but it often succeeds or fails on the drama created by the composition and use of colour. In this work, our artist has managed to capture the vibrancy and impressive scale of the blooms.

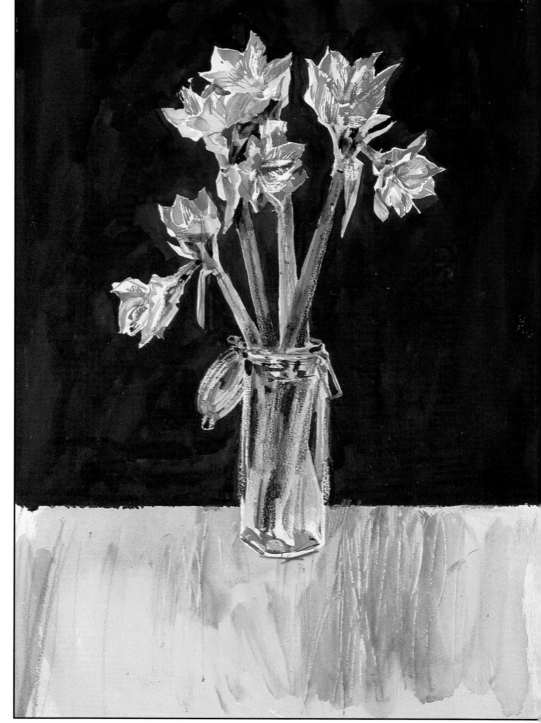

Rapidoliner pen and wash

Pen and wash is a highly effective mixed-media technique. With a Rotring Rapidoliner pen and a selection of watercolours you can exploit its potential still further.

The use of pen and ink with watercolours has always been popular, since it allows the artist to combine crisply drawn lines with the transparent, fluid qualities of the paint. In this way the watercolour is given structure and the drawing depth and substance.

Artists usually use a dip pen and ink for this technique. Though you can achieve some lovely and varied effects with the dip pen, there are a couple of drawbacks, the chief of these being not only the bother of the dipping process itself, but the scratchiness of the nib and the unevenness of line it creates. Moreover, many of the inks used are soluble, and 'bleed' into the paint.

The ink in Rapidoliner pens is waterproof. Once dry, you can paint over drawn lines in the sure knowledge that they won't run. In addition,

Rapidoliner pens have the precision and even ink-flow of the technical pen, but with a more flexible nib. For while most technical pens produce hard, mechanical lines which aren't suitable for all subjects, the Rapidoliner enables you to vary the types of line you make, either by altering the pressure on the nib or by using the side of it.

In the demonstration below it was possible to create feathery, undulating lines for the flowers and fabrics, yet also to produce harder lines for the porcelain and glass vases. The different textures implied by the drawn lines add to the force and variety of the finished painting. At the same time, by limiting herself to pure outline, our artist was able to emphasize the patterning and highly decorative aspects of her subject.

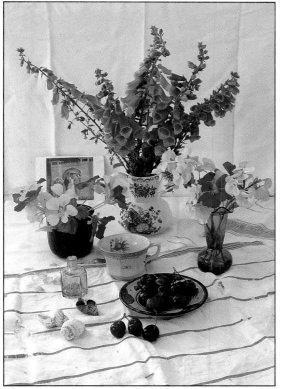

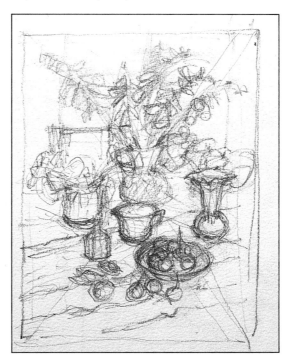

◀ **The set-up** This is a fairly complex arrangement of flowers and different containers. As a guide, bear in mind that the dominant colours are reds, oranges and pinks. Splashes of complementary blue and green on the vases and plates are introduced only to emphasize these principal colours.

◀ Our artist made a quick sketch before she started her painting. This enabled her to confirm the scale and location of all the items and to ensure that the composition would work. It's also a good time to practise those ellipses and iron out any potential problems.

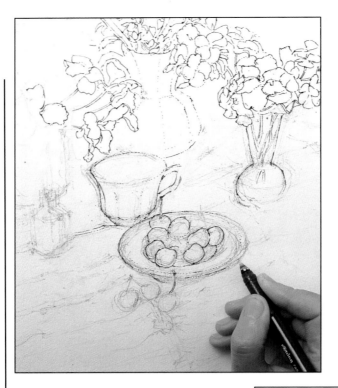

YOU WILL NEED

- [] A 23 x 16in sheet of Arches HP watercolour paper
- [] A 2B pencil
- [] A 0.35mm Rotring Rapidoliner pen
- [] Soft eraser
- [] Two brushes: No.4 and No.6 round
- [] Twenty-one watercolours: lemon yellow, aurora yellow, cadmium yellow, yellow ochre, cadmium orange, cadmium red, permanent rose, permanent magenta, alizarin crimson, cobalt blue, cerulean, Antwerp blue, French ultramarine, Prussian blue, sap green, viridian, Hooker's green dark, Winsor emerald, light red, raw umber and Payne's gray

◀**1** Make a light pencil drawing of the set-up, using a minimum number of outlines and no shading. Continually check the shape and scale of each object in relation to the others, bearing in mind that the negative shapes or spaces between the objects are just as important.

When the pencil drawing is complete to your satisfaction, change over to the Rapidoliner penand start to draw over the most established outlines.

▶**2** Notice how much detail the artist has put into her ink drawing, plotting every petal and even the spotting inside the foxglove flowers. Remember that the pen line is permanent – so be absolutely sure of your pencil drawing (though you don't, of course, have to follow the pencil lines exactly).

Use the soft eraser to rub out the pencil lines.

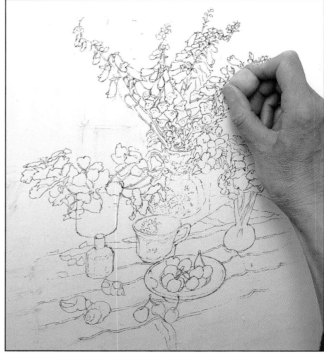

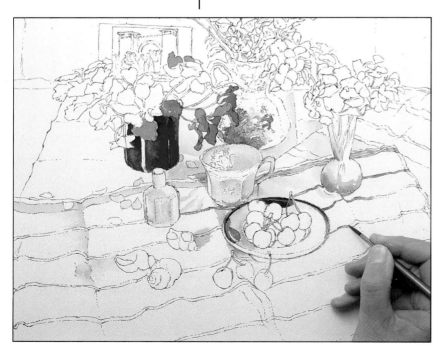

◀**3** Begin painting in the centre of the composition and work outwards. Use pale tones first. Paint the shadows on and around the plate with the No.4 brush and a washy mix of Payne's gray, cobalt blue and alizarin crimson. Add a little Antwerp blue and lemon yellow to this mix for the cooler shadows on the striped cloth. Paint the nasturtiums in a variety of reds and oranges mixed from cadmium red, cadmium orange, alizarin crimson and light red. Mix a blue from Payne's gray/French ultramarine and paint patches on the vase, cup and plate.

Then paint the red stripes in a mixture of cadmium red and permanent rose. For the green vase mix varying quantities of lemon yellow and viridian.

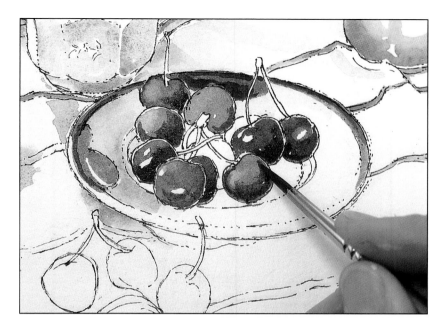

4 Change to the No.6 brush. To make the cherries look round and shiny, leave patches of white paper for highlights. First paint the fruit with a weak mixture of permanent rose, French ultramarine and alizarin crimson, varying the mixture to obtain the slight colour variations in the cherries. Flood darker blobs of this colour into the wet paint for the shadows.

Notice how our artist leaves narrow white outlines around the cherries to differentiate each one.

5 Move on to the rest of the nasturtiums. Use the No.4 brush to paint the yellow blooms in aurora yellow, and the orange and red flowers in mixes of cadmium red, light red and alizarin crimson. There's no need to follow the black outline precisely – the flowers will look more lively if the paint floods its boundaries here and there. Paint the stripes and dark patches on the red and orange nasturtiums with a stronger mixture of the same colour.

6 The main colours are now established. Stand back and assess what you've done. It's time to start working out from the central area to develop the peripheries.

Using a weak magenta wash, pick out a few of the foxgloves at the centre of the composition.

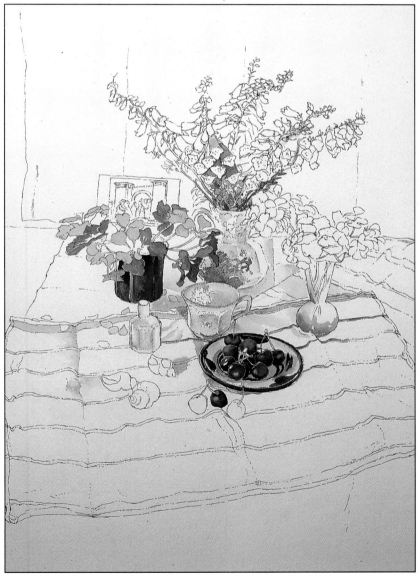

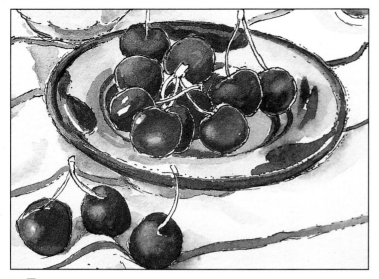

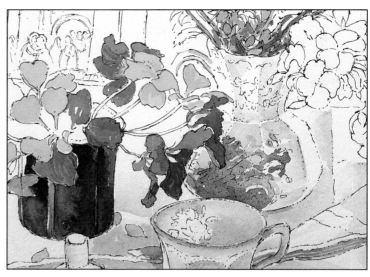

7 Paint the cherries lying on the cloth with the same colour mixes you used for those in the bowl. Suggest shadows around the cherries in diluted washes of colour. Paint more red stripes on the cloth using the No.4 brush and the same mixture of cadmium red and permanent rose, looking carefully at the kinks caused by the creases in the cloth. Vary the strength of colour to suggest light and shade on the cloth.

8 This close-up shows the work that was being done on the centre of the composition. Notice how the subtle shading on the china creates a good impression of depth.

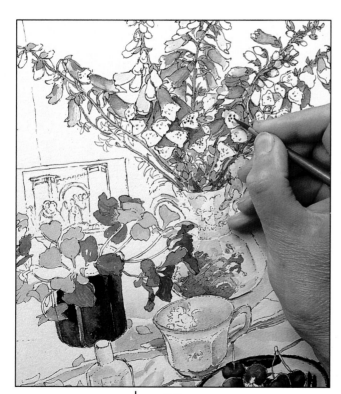

9 Moving upwards, continue to paint the foxgloves with dilute magenta. While the magenta is still wet, drop blobs of permanent rose into those areas where the colour is noticeably darker. Allow this to dry, then paint the leaves in dilute sap green; emphasize the dark areas with a mixture of sap green, Hooker's green dark and Payne's gray. Bring the foxgloves to life by putting tiny dots of magenta in the centre of each flower.

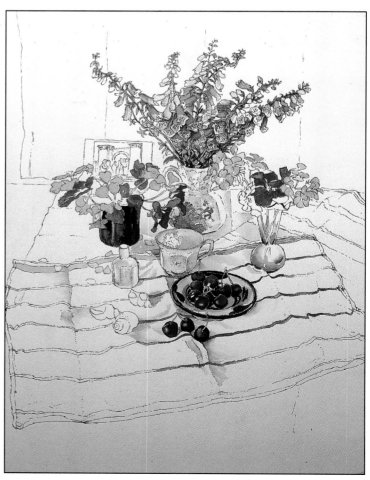

10 Use the No.4 brush to paint the pink geraniums lightly with a washy mixture of magenta/permanent rose and cadmium red/permanent rose. Then stand back and consider what else needs to be done. Most pressing, perhaps, is the table top, which should be developed so the items have something to stand on.

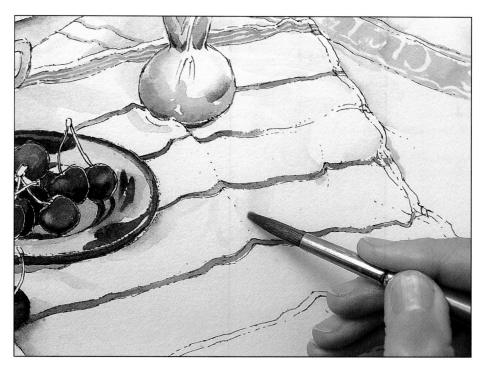

◀**11** Start by painting the diagonal stripe on the far cloth in a mixture of lemon yellow and viridian – use the No.6 brush for this. Look carefully at the shadow colours, and notice how the light falls on the creases in both cloths and the shadows this creates. Develop the shadows in diluted neutral washes mixed from colours used elsewhere in the picture.

▶**12** Return to the glass vase and, using the No.6 brush, build up the stem colours in mixtures of sap green, Hooker's green dark, cadmium yellow, emerald and viridian; develop the blue pattern on the vase using the original colours. Also develop the shadows and reflections on the small glass bottle with washes of Hooker's green and magenta. Define the backcloth lightly with washes of yellow ochre and Payne's gray, adding touches of magenta, French ultramarine and other colours on the palette.

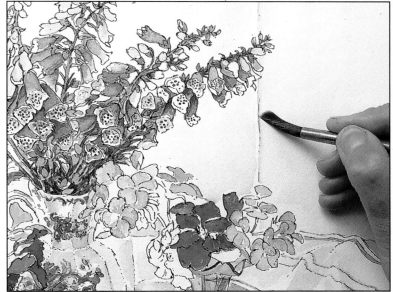

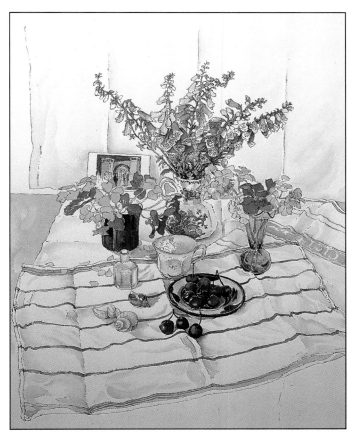

◀**13** Change to the No.4 brush and paint the two shells on the left in mixtures of yellow ochre and raw umber, emphasizing the striped markings to describe the rounded forms. Use the same colours with touches of Payne's gray and French ultramarine for their shadows on the cloth.

Paint the third shell with a mixture of Payne's gray, French ultramarine and Prussian blue. Touch in the postcard in the background with dabs of cobalt blue, cerulean, Winsor emerald, raw umber, yellow ochre, light red and some sap green.

▶ **14** Use the tip of the No.4 brush and a dark mixture of cadmium red and Hooker's green dark to paint the cherry stalks. Touch in the nasturtium stalks with sap green and cadmium yellow.

Still using the tip of the brush, dot in the pattern on the teacup with the pinks, greens, yellows and blues used elsewhere in the painting. Deepen the shadows on the outside of the cup with mixtures of viridian, Payne's gray, Antwerp blue and yellow ochre.

▼ **15** The picture is nearly finished. Go over the painting, darkening any tones which need strengthening. For example, the dark blue of the cherry plate needs to be darkened with a mixture of French ultramarine and Payne's gray.

▶ **16** Finally, emphasize the tones of the nasturtium petals, the foreground shadows on the cloth, and any other areas you feel need darkening or brightening in relation to the surrounding colours.

The finished picture is a delightful combination of bright, jewel-like colours and definite lines. The Rapidoliner and wash technique turns it into a coherent and highly decorative whole.

Fine lines, delicate washes

Mixing two media can often bring out the best in both – as here, where fine ink work and soft watercolour washes combine to produce a drawing of great charm and delicacy.

As we have already seen, transparent watercolour partners ink extremely well. Both mediums have an intrinsic delicacy which gives the drawing a light touch and ensures that neither medium overwhelms the other. At the same time, the strength and vivacity of pen and ink contrast well with the translucency of watercolour.

You may choose to use a Rapidoliner pen as shown in the last project; here our artist has chosen to work with a classic dipping pen and ink.

Our artist chose to use brown ink, which is softer than black and mixes well with watercolours – harmonizing particularly well with earth colours such as burnt umber, yellow ochre and raw sienna. Her gentle washes aim to catch a sense of the structure and bulk of buildings, bridges and water.

Both the watercolour and the pen detailing are worked quickly – our artist wanted to catch the spirit of the place rather than render elaborate detail. Throughout, her concern was to keep the balance of tones right. Some of her colours stray from those in her photo, but this was done deliberately for enhanced effect.

▼ **Using waterproof brown ink for the linear details and transparent watercolour for mass and tones, the artist has captured the spirit of this picturesque canal-side scene.** *'Campo Santa Maria' by Lynette Hemmant, ink and watercolour on paper*

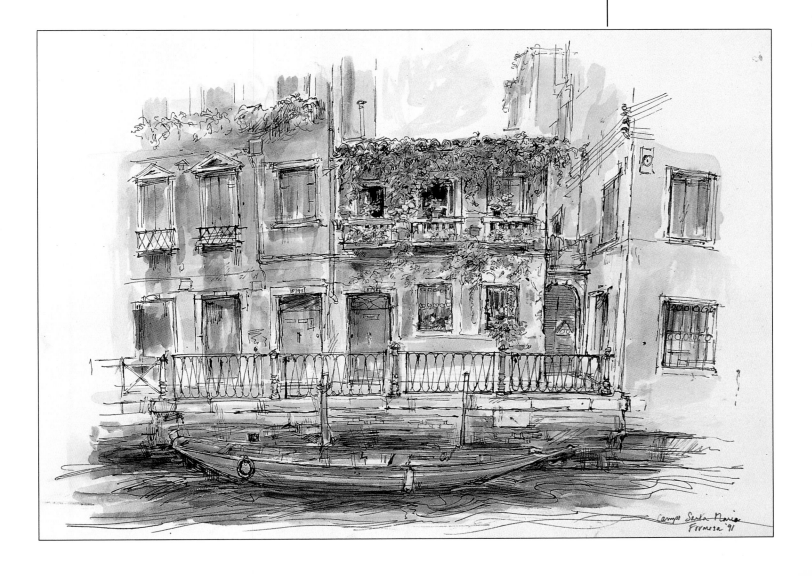

Room with a view

YOU WILL NEED

- A pad of good quality cartridge paper, such as Jubilee
- An HB pencil
- Winsor & Newton Peat Brown ink
- A dip pen and nib of your choice
- Two jars of water
- Kitchen paper
- Two sable brushes: Nos. 8 and 5
- Six watercolours: terre verte, burnt umber, yellow ochre, Venetian red, cobalt blue and viridian

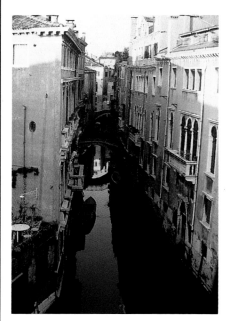

The set-up Our artist snapped up the opportunity to stay in Venice in a house with this wonderful view. Sketching from a balcony or window gives you comfort, privacy and some welcome shade.

1 Lightly pencil in the position of the buildings, bridges and canal. Now liberally apply a series of thin watercolour washes with your No.8 brush, allowing them to run into each other softly to create delicious new colour mixes – our artist used terre verte, burnt umber and a touch of yellow ochre. These washes establish some of the tones and prevent you from getting too carried away with the pen details at this stage.

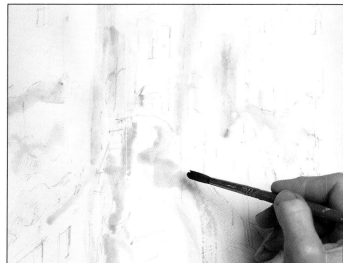

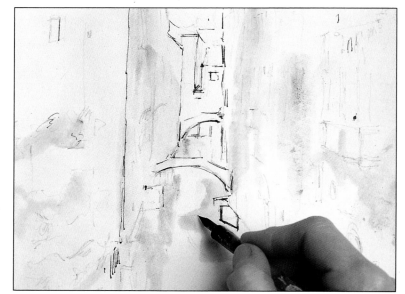

2 Once the washes are dry, define the buildings with your dip pen and ink, just putting in the basic outlines. (If the washes are still wet, the ink will run – though you can use this to your advantage.) Don't simply trace over your pencil marks or the result will look flat and mechanical. Keep your pen work lively, using the pencil lines only as rough guides.

3 Carry on building up tones, introducing washes of cobalt blue, viridian and Venetian red and adding more yellow ochre. Then elaborate the existing pen lines slightly.

Our artist used colour creatively to link different areas – the cobalt blue on the canal is echoed on the roof tops, for example. Most of the washes are applied wet-on-dry, but some wet-in-wet washes soften the effect and create new colour mixes as the wet washes blend.

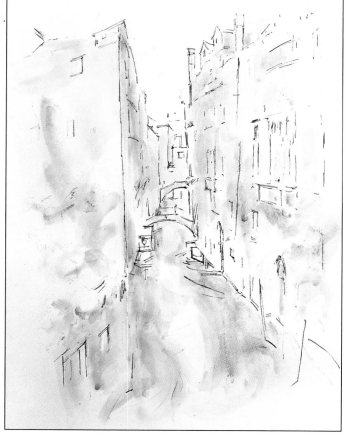

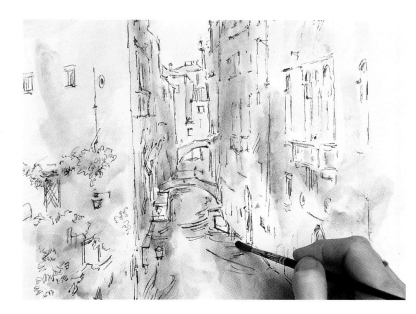

◄4 Taking care to keep things spontaneous, work on the details – roofs, windows, balconies and window boxes – with pen and ink. Use the pen freely, and vary your strokes so the marks suggest the subject. Our artist rendered the plants on the left with loose scribbles and the window panes with long, straight strokes; a little cross hatching emphasizes darker tones.

Add more delicate washes of colour – thin cobalt blue for the sky and more yellow ochre, burnt umber, Venetian red and blue on the buildings.

Tip

Wet wash
If you apply your washes liberally, as our artist did, you may get a few runs. Keep

some kitchen paper on hand so you can soak up any trickles of paint before they stain the paper.

►5 Carry on in the same manner, alternating washes of colour with pen and ink, and working on all areas of the picture to maintain the balance of ink and wash. Keep the washes fairly light so they don't dominate, but don't be afraid to go over them with another wash of the same colour if you wish to add more depth, as our artist is doing here with the sky.

▼6 Add a few splashes of colour where you think your sketch needs it. Our artist added flashes of Venetian red for the geraniums on the balcony, and balanced it with a little Venetian red on the gondola under the bridge. Some extra pen lines give the geraniums more substance and weight.

▼7 Work in a few more details – our artist refined the balconies and emphasized the lamps to accentuate the Italian feel. She also put in a couple of figures on the first bridge and another on the second in pen and ink. These rather endearing figures add scale. Notice that the pen marks are light, not heavy handed.

8 Strengthen some of your lines to suggest shadows and to convey the crumbling condition of the stonework. If any of the tones need more depth, use your No.5 brush to go over the washes again with the same colour. Don't go over the wash exactly – you get much more variety if the edges don't match precisely. Leave the washes to dry thoroughly.

Now touch up any details with the pen, being careful not to overdo things. If it looks good as it is, don't change it.

9 The final sketch captures the atmosphere of this romantic canal in Venice without actually copying it detail for detail. There's enough information to convey the style of the place and to suggest the different textures – the smooth, murky water, crumbling stonework and flourishing geraniums – but not so much that it looks overworked.

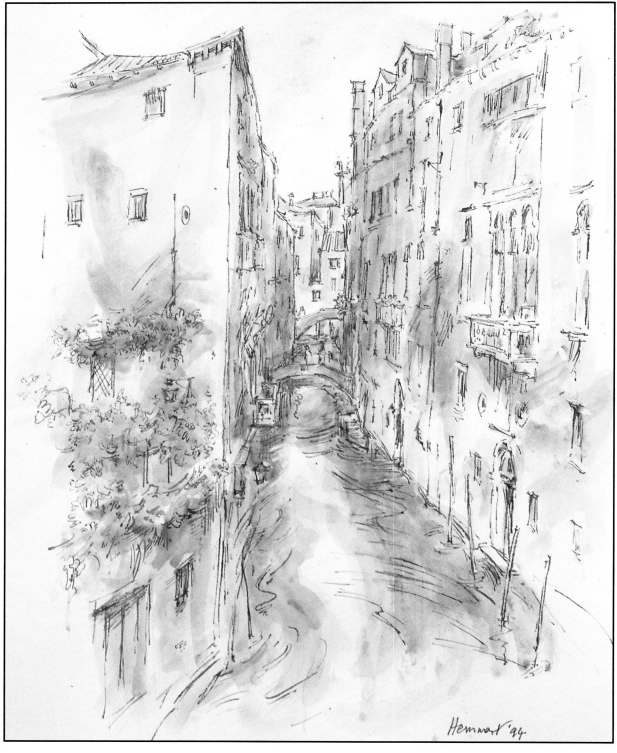

Hemmart '94

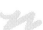

Self-portraits in watercolour

Portraits aren't restricted to the use of oils. Try watercolours for a spontaneous fresh approach.

Many people like to keep a diary, so that in years to come they can look back at their experiences and follow the changes in their outlook and the way they think. Artists often achieve the same end by painting self-portraits. Undertaken regularly over time, these can show a gradual ripening and mellowing of both face and character. Sometimes, however, they can tell a sad story – Rembrandt's self-portraits in oils show his decline from wealthy, cocksure young artist to disillusioned, poverty-stricken old man.

Even if your circumstances are better than Rembrandt's, models can be quite a costly luxury. For many artists, painting self-portraits means they have a free and reliable model, willing to work long and unsociable hours. With this in mind, you can improve your portraiture skills at any time.

With commissioned portraits, the pressure to 'succeed' or flatter can constrain artists to stick to tried and tested techniques. So another good reason for self-portraiture is that it gives you freedom – both to be completely truthful and to experiment.

Using watercolours

Perhaps the reason why so many portraits are painted in oils is because oil paint as a medium is more forgiving than watercolour. Yet the delicacy and translucency of watercolours can bring out the freshness of skin tones and capture an immediacy of expression – a fleeting glance or look. If you are your own model, you can try your hand – without pressure – at mastering this lovely medium for portraiture.

Setting up

When you come to compose your painting, think about the many choices open to you. Do you want to show the mirror in the picture? If you do intend to paint the edges of the mirror, what shape would be best for your purposes?

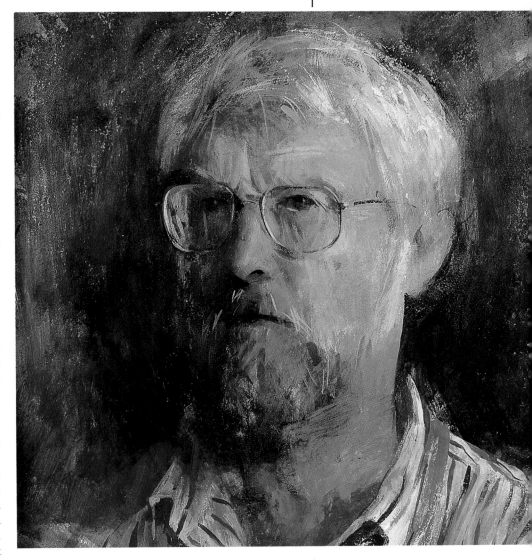

Do you want a full-length view or head and shoulders, and should you be seated, standing, full-face, three-quarter view, tilted head and so on?

Don't neglect your surroundings. Backgrounds should give a sense of enclosing space – how do you intend to do this with your background and what do you want it to say about you? Choose, also, whether you want a formal or relaxed setting.

▲ **Adding white paint gives watercolours more opacity, and creates a good consistency for texture-making – ideal for a bristly beard.**
'Self-portrait' by Leslie Worth PPRWS, watercolour, gouache, gum and size, 9½ x 9in

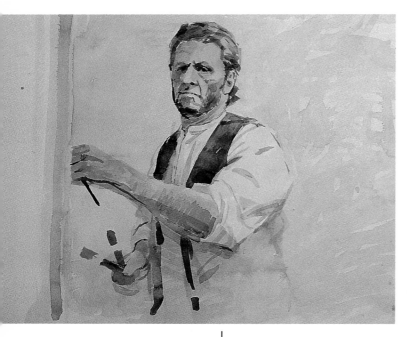

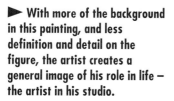

▲ This painting focuses on the artist and his drawing by eliminating everything else. The background, although lively, with loose brushstrokes, sits back, keeping the emphasis firmly on the act of self-portraiture.

You don't have to stick to the portrait (upright) format just because you're painting a portrait. If you want to make a feature of the background, a landscape or square format allows you to include more of it. Or you may want to try an unusual format – an oval, for instance.

Used creatively, lighting can help you achieve the mood you want in your painting. Consider how you want yourself to be lit, but remember, you are the artist as well as the subject – it's no good having a dramatic side-light if you can't see the support or the colours on your palette.

Your support should be flat or set at anything up to a 45° angle, so your washes don't run riot across the page. Try to find a position in which you can see your support as well as yourself in the mirror with ease. If you want to paint yourself as people see you, rather than your mirror image, you'll have to put some thought into arranging two or three mirrors, yourself and your support

▲ Here the artist shows himself with a serious expression, suggesting his concentration on the work at hand. His cocked eyebrow gives him a quizzical air.

for comfort. Then make sure all your equipment is close at hand, so you don't have to move much once you start painting.

The best policy

Forget about vanity – honesty is a much more worthy and educational approach to self-portraiture. Try to detach yourself from the face you see in the mirror, as if you've never seen that face before. Sometimes, your own appearance can be unexpected. If you're as honest as you can be, and paint what you truly see (rather than what you think you see, or would prefer to see), both your mood and your character automatically come across – which are arguably the most important aspects of all in portraiture.

▶ With more of the background in this painting, and less definition and detail on the figure, the artist creates a general image of his role in life – the artist in his studio.

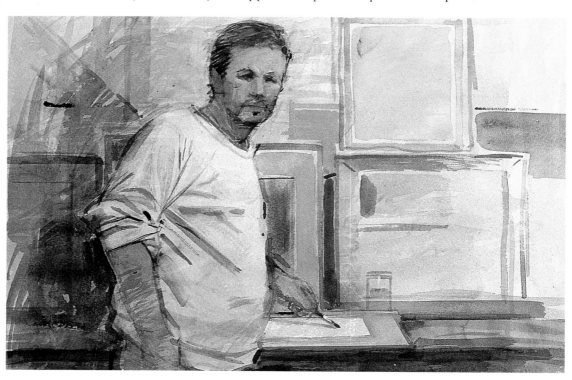

Mirrors and faces

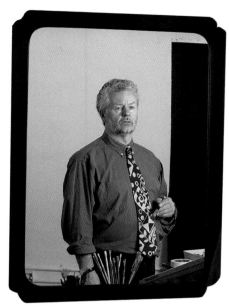

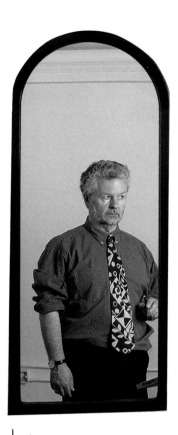

▲ You can't cram in too much information with a small mirror — only head and shoulders — so the emphasis remains on the face. A small round mirror like this can be used to create quite a strong self-portrait. The face will be close to the viewer (with a larger mirror, you'd probably stand farther back).

▲ If you want to spin more of a tale with your self-portraits, a large oblong mirror will allow you to stand farther back to include more of yourself as well as more background. With less emphasis on the face, this type of format is not as intimate as with a small mirror, but it means you can record a few details.

▲ Long, thin mirrors can be used when you want to keep the emphasis on yourself, but prefer to show more than a small mirror allows.

Alternatively, use the shape for an unusual image, showing a reflection of yourself in, say, the lower part of the mirror, filling the upper part with the room behind and above you.

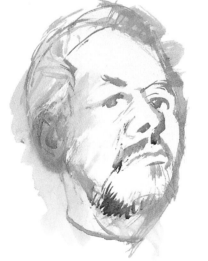

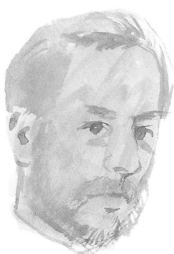

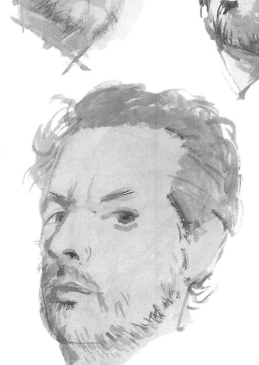

◄ Often, self-portraits have an odd, rather staring quality because the artist must focus closely — stare hard — at his or her own face. It is difficult to make a self-portrait look natural or cheerful. Apart from anything else, you feel a bit of an idiot grinning away at yourself in the mirror!

The intense concentration of our artist comes through in these quick studies. Notice how each pose is slightly different. For instance, he propped the mirror at a low angle beneath his face for the second sketch (above centre).

If you're making quick studies such as these, try using different colours each time for the skin tones to see the results of each combination.

Gridding for accuracy

Achieving correct proportions can often be a challenge, even for experienced artists. With portraiture there is pressure to get things right, since it will be very obvious if your shapes and proportions are wrong. (The accurate 'likeness' is often the first thing to go.)

If you have difficulty with this, try the gridding system that our artist used here. Draw a grid on the mirror, then replicate this on the paper. All you have to do then is draw exactly what you can see in one block on the mirror in the corresponding block on your paper.

You need to stand in exactly the same spot throughout the painting, or you'll end with a rather peculiar jumbled-up version of your face! You may find it helpful to mark the position of your feet with masking tape or chalk to help you step back into place when you've stopped for a break.

▶ Our artist drew this grid on his mirror with acrylic gesso. Each block was one inch square, and the proportions of the grid were eight blocks by twelve. He then numbered the grid, on both the paper and the mirror, to make it easy to locate corresponding blocks on the paper.

▼ As the painting developed, our artist continually corrected his initial drawing, especially the eyes and glasses. He also put in the edge of his drawing board. Once he was happy with the basics, he started on the background.

◀ Here our artist begins his self-portrait by drawing exactly what he sees in each block, starting with the two nostrils. Using a fine watercolour brush and dilute ultramarine, he placed the important features first – the nose, eyes (and glasses), ears and mouth – then went on to indicate the collar and hairline.

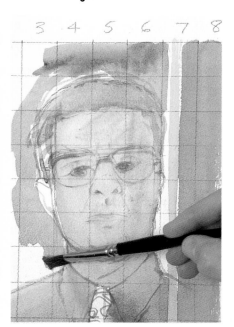

▶ With everything in place, our artist elaborated the details, tidying them up and bringing them to completion. He worked up the details of the face, and also the clothes and hair.

You can see in the final picture that the proportions are quite accurate. Although this can be an awkward way of working, because you may have to stop to work out which block is which, it is a good system to try if you have difficulty with proportions. Once you have more confidence, you can move on to working freehand.

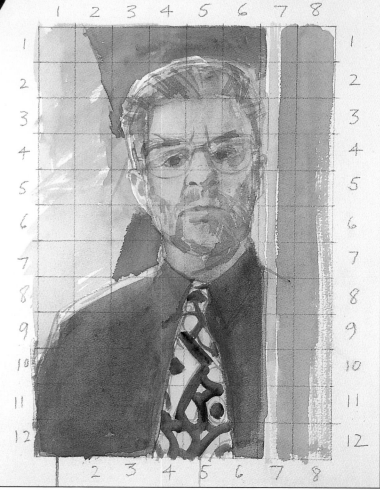

Michael's self-portrait

Our artist, Michael Whittlesea, paints self-portraits regularly. He says that looking at himself with detachment and honesty is a challenging and rewarding exercise.

"It doesn't matter what the results are like – good or bad. It's not for others to see. The point is to have a really good look and a good paint.

"I generally begin with a few thumbnail sketches to establish the composition, then I draw in the basic facial elements in charcoal – this is less 'hit and miss' than jumping straight in with watercolour paints.

"When it comes to painting, I like to search out the elements that I might ordinarily prefer to ignore, such as red noses and pink cheeks over a white neck. It's these delicate variations in colouring that make anyone a fascinating subject for portraiture."

The set-up Position yourself so you can alternate between looking in the mirror and looking at your support with no more than swivelling your hips or turning your face. Since you're the model, the less you move the better. Once you finish your drawing, keep your board at an angle of about 45° – or lower, if possible – so your paints don't run. Working flat can be a little distorting since you can't really see your support clearly, so lift up your board from time to time to assess your picture.

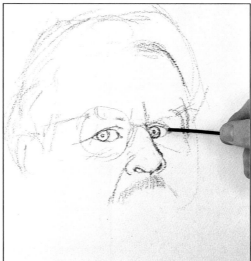

1 Draw the facial features with a thin stick of charcoal. Our artist started at the hairline, then moved down towards the face. Don't worry too much about details at this stage, just place the basic features. Take your time with the drawing, and concentrate especially on getting the triangle between eyes and nose correct.

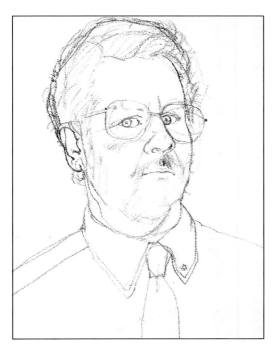

2 Work down the face to define the mouth and chin, looking carefully all the time. Once the basics of the face are in, move towards the collar, tie and shoulders. Then, with the drawing more or less established, scrub in some tones, perhaps on the cheek and hair as here. You may wish to indicate details such as beard, eyebrows, facial lines or beauty spots. Notice how the artist has sharpened certain outlines – the forehead, cheek and neck to the right, and to the left the outline of the hair leading down to the ear.

Make sure you draw exactly what you see. Our artist's glasses were sitting on his face at an odd angle, so he drew them in that way.

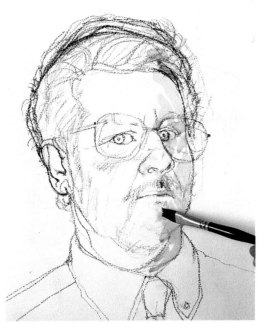

3 The artist preferred not to fix his drawing, since overfixing causes the paper to resist watercolours. Charcoal marks bleed with paints for quite an appealing effect.

Before you start to paint, look hard at your face and break it down into broad areas of colour. Establish where the main source of light is, and how it affects what you see. The light shines from the left here, so the artist lays a wash for the shadow on the right side of the face with a pale mix of alizarin crimson, yellow ochre and viridian. He used a ½in flat brush to stop him from fiddling, making short strokes to stop the picture becoming too wet and getting out of control.

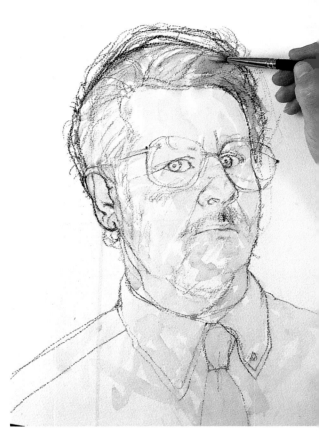

4 Once you've applied a skin tone, consider where else you can use the same hue. The artist used the pinkish wash to pick out patches of shadow on the cheek to the left and on the ear. He didn't reserve this colour for flesh tones only – he touched some into the hair and on the front of the shirt for dark tones. It's good practice to keep the whole painting going in this way, rather than concentrating on one spot.

Now that he had started on the shirt, the artist put a base wash over the tie using Naples yellow dirtied with viridian. He added more viridian to make a warm grey for the hair.

5 The artist didn't want a busy background that would detract attention from his face, so he opted for a plain one. Here, the darker grey is made from alizarin crimson and viridian, which he used to give a background tone, making loose, rough strokes.

Consider where else you can use the same mix. Our artist found the background grey useful for emphasizing the dark tones on the shirt.

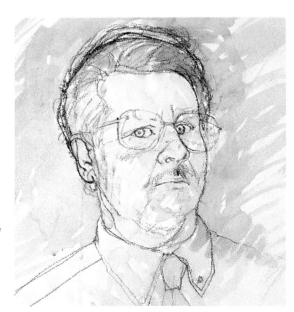

6 It's helpful to wipe your palette clean with kitchen paper, to avoid muddying colours and adulterating flesh tones. The face should be dry enough to continue working with a few flesh tones.

Look again at the delicate tonal and colour variations across the face. Our artist used varying dilutions of alizarin crimson and cobalt violet to emphasize some dark patches on the forehead and cheek. He picked out slightly paler tones with a viridian/alizarin crimson mix, and used ultramarine/cobalt violet for the irises, the hollows of the eyes and the brows.

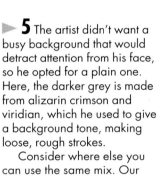

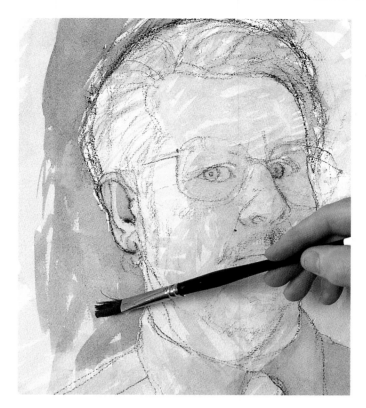

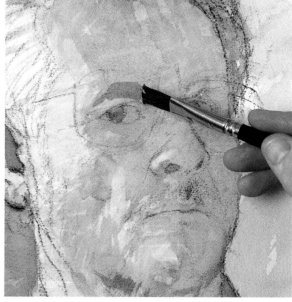

7 Continue with the flesh colours, building up the tones gradually. The artist used the ultramarine/cobalt violet mix in the hair, across the face, on the shirt and in the whorl of the ear. He diluted the mix for the tie pattern. Then he loosely scrubbed a grey (alizarin crimson/viridian) on the background to the left. This pulls the figure forward and balances the tones on the face.

8 As you can see, our artist sticks to a fairly limited palette, recycling his mixes where he can. Use your washes to carve the contours of the cheeks and chin, using the directions of your brushstrokes to help you. Look hard for the tiny touches of tone and colour – the deep shadows in the ear and nostrils, the darker tones beneath the chin, and the slight variations in hue across the face. For the darker shadows, he added some alizarin crimson to his blue/violet mix. For paler areas on the cheek he used neat alizarin crimson.

Start to pick out details. The artist defined some outlines with the edge of his brush, and put in the eyebrows and the beard. Develop the clothes – here, ultramarine brings out the depth of the colour of the shirt, and alizarin and ultramarine indicate the pattern on the tie (see step 9).

9 Look again at your painting. Don't assume your face is symmetrical – this is actually quite rare. Look hard for the asymmetrical qualities in your face, especially around the eyes, and make sure you've captured them in your portrait.

Work around the painting, adding the final details. The artist develops the eyes with a deep blue. If you need to pull highlights out of the paint, you can do this with a clean, damp brush.

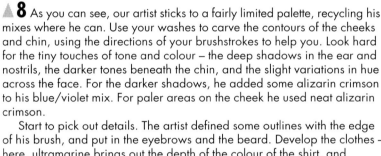

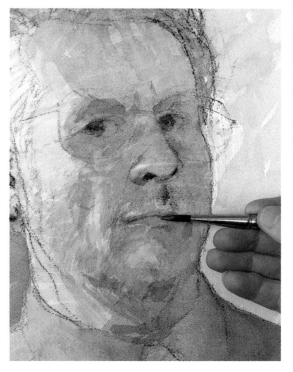

10 Tighten details of your clothes and the background, then look at the facial features. Do they need firming up? The artist used a grey to reclaim the jawline and eye sockets.

Are there any areas that need softening? Continue picking out the contrasts of tone across the face, using them to mould its form. Also try to bring out the subtle nuances of skin colouring by modifying the washes. Put in the colour of the lips.

◀11 Even at this last stage, the artist put in many adjustments that made quite a difference. He brought out more of the strands in the hair and beard with grey, and worked across the cheek, nose and chin adding the darker tones. He also defined the edges of the glasses and added the wispy strands of hair on the nape of the neck.

Tip

Quick line-up

If you're using the gridding system for your self-portrait, you'll notice that each time you raise your head from your support to look in the mirror, you have to reposition yourself so that you are in the right place. This can be quite a nuisance, especially when you get into the swing of painting. To make the whole thing quicker and easier, do as our artist did – use a bright colour to paint a dot on the mirror where the tip of your nose is reflected. Then, each time you raise your head, just line up your nose with the dot.

▶12 Using the freshness and immediacy of watercolours, the artist has captured quite a good likeness of himself here – have you? If not, don't worry. With yourself as a model, you can keep on trying as often as you like. You'll find that you reach a stage when your self-portraits come together.

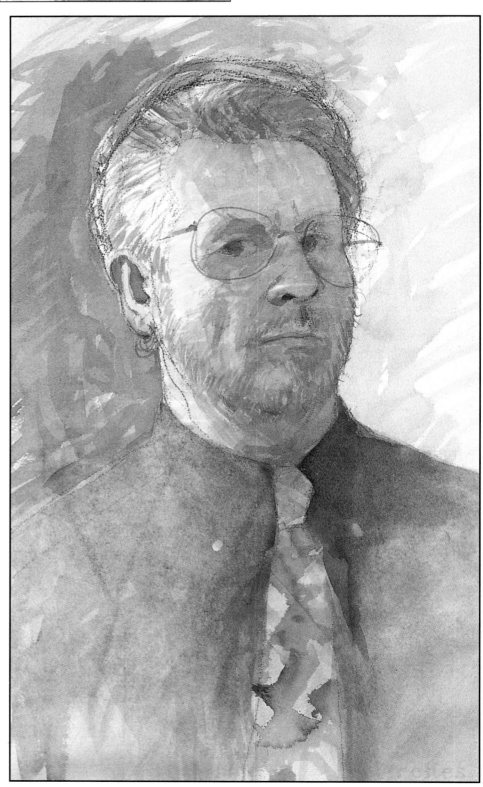

Portraying children in watercolour

Oil paint is often thought of as the standard medium for portraiture. But for some really delightful informal portraits of children, the translucency of watercolour is ideal.

Traditionally, the lavish, tactile quality of oil paints has been used to give a solid, realistic rendition of a sitter. Since you can rework oils, it's also possible to produce a very faithful and detailed portrait.

However, if you want to capture a spontaneous impression of a person's likeness, watercolour comes into its own. The freer brushstrokes and the more delicate colours are particularly suitable for touching portraits of children.

Impressionistic effects

For a truly impressionistic portrait, try working without an initial drawing. This means the sittings should rarely last more than an hour, which is ideal when working with restless children.

However, since watercolours can't be reworked to any great extent, it takes some practice to paint without a drawing. So it's essential to check the proportions of your sitter carefully before you start.

The best way to do this is by simply holding a pencil or brush up to your sitter, and measuring the various features by sliding your thumb up and down. Try starting with a head-and-shoulders portrait, as our artist has done, since the proportions are not as difficult as a full-length composition. Remember that the bottom of the nose should line up with the tip of the earlobes and that there should be about one eye's width between the two eyes. Get these particular measurements right, and you are halfway to achieving a reasonable likeness.

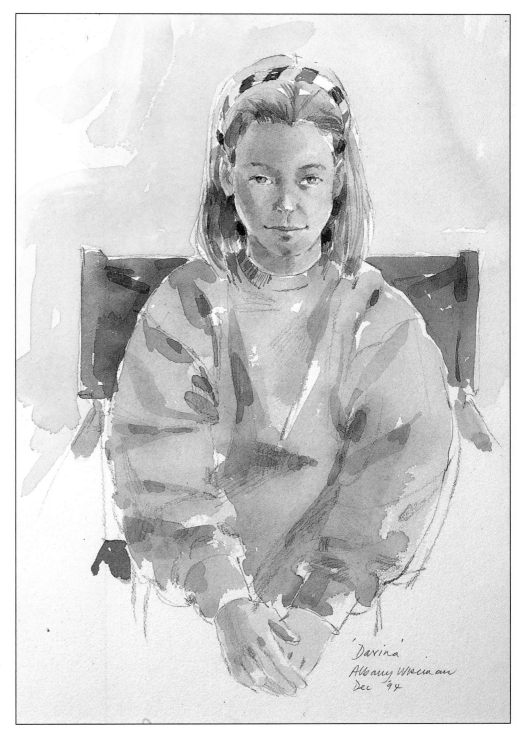

► Gentle watercolour washes are perfect for producing delicate portraits of children. Note how the artist here has used short, bold brushstrokes for the shadows which add greatly to the liveliness of the picture.
'Davina' by Albany Wiseman, watercolour on paper, 297 x 420mm (11¾ x 16½in)

Anna's portrait

More often than not, the major problem in painting children is getting them to stay still. Of course, it's perfectly acceptable to paint from a photo, but you may find yourself labouring over the portrait and losing some of the spontaneity.

One solution is to paint a child who is engrossed in a television programme. This often gives a perfect facial expression, as if the child is just sitting and thinking. (Make sure the expression isn't too vacant though!)

In line with traditional watercolour practice, start with broad areas of very dilute colour. This is particularly important in children's portraiture, where you want to capture the translucent delicacy of the skin tones and the softness of the facial features.

Paint the overall shape of the head first, then gradually build up colour. Don't be afraid to leave some areas of the paper white to create striking highlights. Our artist left white paper showing in Anna's hair, forehead, eyes and chin.

To produce a crisp, definite likeness, make sure that the previous colour has dried before adding any more. However, try not to 'muddy' the image with too many colours. Also, keep reworking to a minimum to maintain the delicacy of the picture.

When most of the initial washes are down and the features correctly positioned, move on to the details. Our artist sparingly added some of the blue pattern of Anna's dress. This is just enough to offset the warmer colours of face and hair, without overwhelming the portrait.

Leave most of the fine brushwork to the final stages. Note how our artist waited until the last two steps before adding some of the most telling details – such as the freckles on the face and the alizarin crimson on the dress.

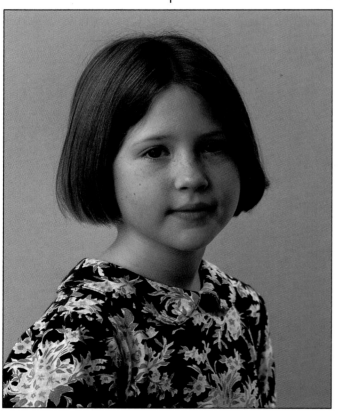

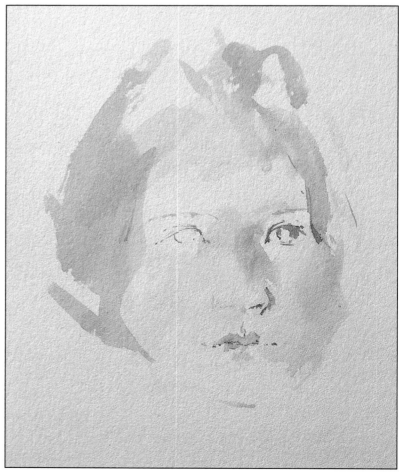

◀ **The set-up** Our artist painted from life, using a diffused light positioned at 45° to the sitter to give the face some modelling. The softness of the light is perfect for producing a tender, romantic portrait of a child. Harsh shadows would have created a much more aggressive picture.

▶ **1** With a light wash of yellow ochre mixed with a little Prussian blue and alizarin crimson, paint the general shape of the head and hair. Position the eyes and nose using very watery paint. If these need repositioning, blot off the paint with thin tissue paper. Mix more alizarin crimson into the wash and begin to paint the cheeks. Add more alizarin crimson and paint in the lips.

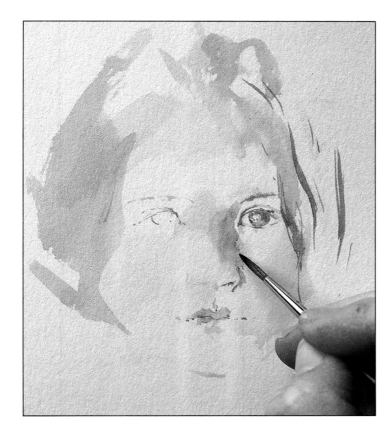

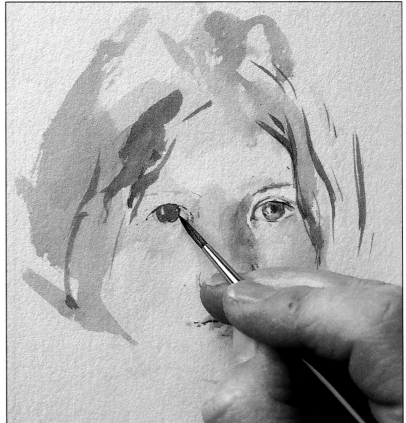

2 Block in the shadow area on the right of the nose and underline the right eyebrow, all in raw umber. Also emphasize the eye with dilute Prussian blue, remembering to leave some white paper showing through for a 'catch' light.

3 Mix some alizarin crimson with the raw umber for sections of the hair. Once the light wash on the right eye has dried, work over it again with a mix of Prussian blue and burnt umber. Shape the eye carefully, outlining the eyelid and filling in the pupil.

Darken the line of the mouth with a mix of alizarin crimson and a touch of burnt umber. Now paint the other eye with dilute Prussian blue, using this colour also for the shadow under the hair.

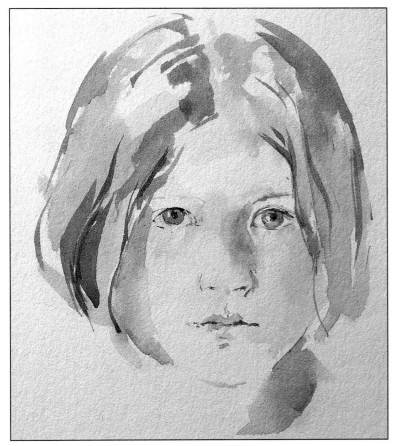

4 To give form to the hair, you need a variety of tones. Mix raw sienna and burnt umber for the deeper areas of shadow, especially near the parting, and also add yellow ochre and alizarin crimson. Once the left eye is dry, work over it with the Prussian blue/burnt umber mix.

To define the line of the chin and give tone to the neck, apply a watery mix of raw sienna and burnt umber with a little Prussian blue.

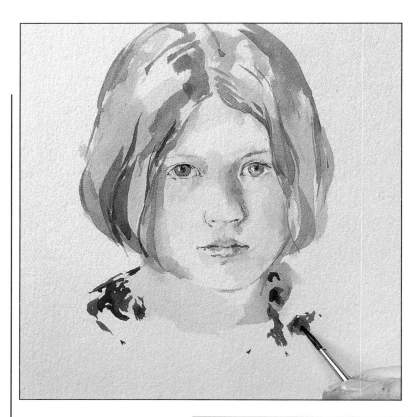

5 Using very dilute alizarin crimson, work around the eyes and beneath the nose. For some colour on the chin and left side of the neck, add very dilute yellow ochre with a little rose madder and Prussian blue. A mix of yellow ochre, raw sienna and burnt umber emphasizes the darker areas where the hair turns under.

Using the fine point on your brush, paint in some of the pattern of the dress with a mix of Prussian blue, French ultramarine and a touch of alizarin crimson. Also work on the shadows under the nose and mouth.

6 Dilute the yellow ochre, raw sienna and burnt umber mix and wash it over the hair to give more body. Leave some areas blank to provide highlights. Use the same mix to improve the line of the chin and the underside of the nose, and to define the dent below the nose and the dimple below the mouth.

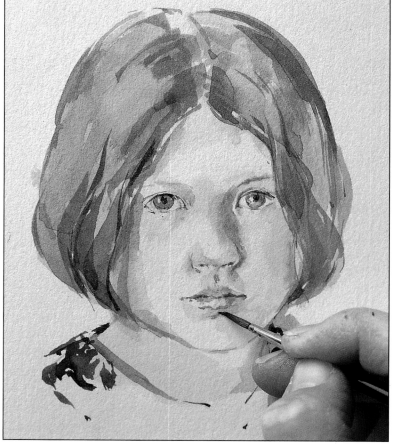

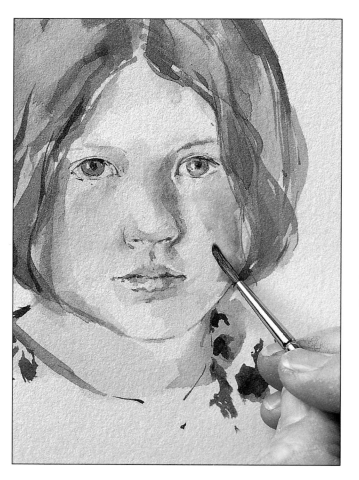

7 To give more warmth and colour to the face, mix rose madder with a little cadmium red and cadmium orange. The effect should be subtle, so wet the area with a little clean water to encourage the colour to bleed into the darker, surrounding tones. Remember to leave some paper showing through for the highlights.

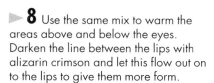

8 Use the same mix to warm the areas above and below the eyes. Darken the line between the lips with alizarin crimson and let this flow out on to the lips to give them more form.

9 For Anna's freckles, dot on a dilute mix of yellow ochre and alizarin crimson with the fine point of the brush. Add a little Prussian blue and burnt umber to this mix for the freckles in darker areas. To complete the picture, put on a few touches of alizarin crimson to pick up the flowers in the dress. Use this colour sparingly – it mustn't draw attention from the face.

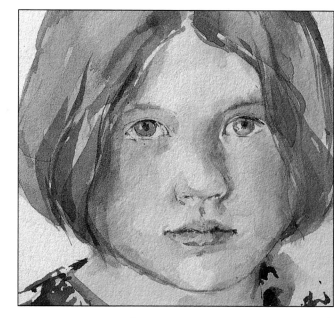

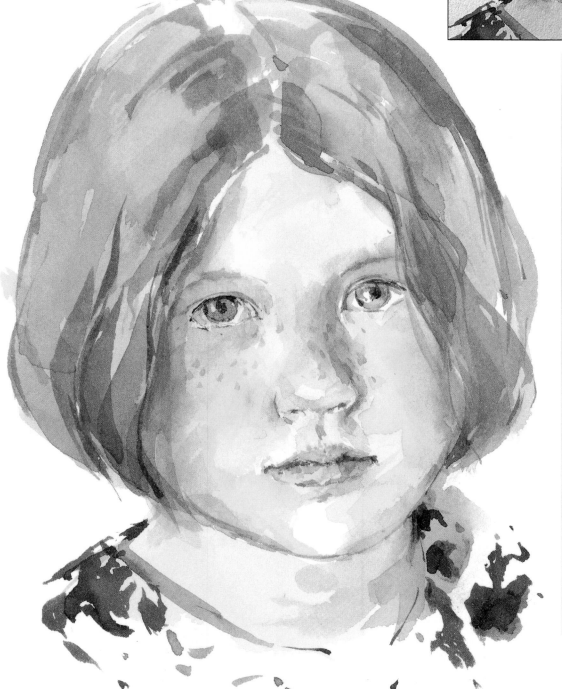

Harry's portrait

To do Harry justice, our artist modified her technique slightly, using more alizarin crimson to emphasize his rosy skin tones. The warm skin colour offsets Harry's blue eyes particularly well. You'll generally find that, as here, the middle sections of the face – the cheeks, ears and nose – have more colour than the forehead and chin.

Harry's hair also required different treatment. Our artist used bold, choppy brushstrokes rather than the more flowing ones used for Anna's longer hair. For Harry's fairer hair the artist added yellow ochre to mix stronger washes than she'd used on Anna's hair.

For the top of the shirt, she painted wet-in-wet, working into her washes before they dried. This obscures the detail and definition of the collar, which would distract from the face.

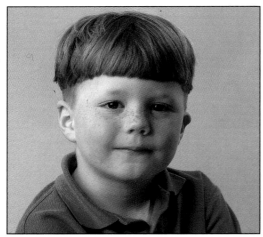

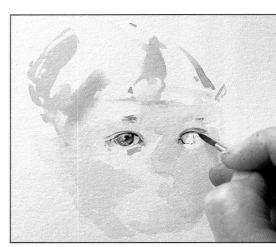

◀ **The set-up** The lighting and pose for Harry was almost identical to that for Anna.

▶ **1** Start with a pale mix of yellow ochre with touches of Prussian blue and alizarin crimson to paint the shape of the head. Use slightly more Prussian blue for the shadows.

Add detail to the eyes in dilute Prussian blue, leaving blanks for highlights. When dry, add burnt umber to the Prussian blue and outline the lids and pupils.

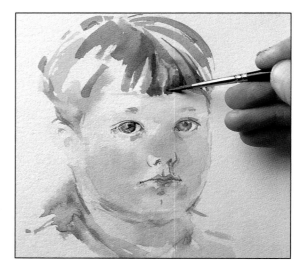

▲ **2** Loosely paint in the shirt wet-in-wet with a pale mix of cerulean blue/raw sienna. Now outline the nose, diluting this for shadow under the chin. Darken the hair with raw sienna and burnt umber, including a touch of alizarin crimson in places.

◀ **3** To capture Harry's rosy cheeks, mix rose madder and yellow ochre. Splay your brush slightly to soften the colour. Then add dilute washes of colour over areas where detail isn't vital. Wash yellow ochre with a little raw sienna over the hair and cerulean blue over the shirt. Finish by defining the ears, nose and mouth more precisely, and dotting in the freckles.

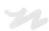

Painting from a photograph

Although you can't beat the experience of painting from life, there are times when it's more expedient, and appropriate, to work from a photograph.

It's possible to create some delightful portraits of children in watercolour – the immediacy of the medium and the translucent colours are perfect for capturing the freshness of youthful skin. But painting portraits is difficult at the best of times, and if there are two things which make it even more of a challenge, it's choosing watercolour as your medium and a child as your subject.

Watercolour is harder to use than many people think because it's so difficult to alter – you can't slim down the face, say, or change the position of an eye once you've advanced beyond the lightest washes. And children are notoriously difficult to work with because they won't stay in one place for long unless they are asleep or glued to a TV screen or computer game.

Luckily you can always make things easier for yourself when you start off. In the following demonstration, for example, our artist started with a large photograph of his subject – Helen, aged nearly two – which he gridded up and transferred to his paper. This cuts out all the

problems of getting such a young sitter to stay still and it helps you make a really accurate drawing. What's more, it will enable you to capture a particular mood rather than the tired, expressionless face you'd probably see after your subject had been sitting still for an hour or so.

Although you could simply copy the painting here, you'll find it means much more to you if you follow our artist's methods to paint a child *you* know. In fact, you could use the same methods to paint an adult, or even a pet animal. Start with very thin washes which allow room for manoeuvre – you can darken tones later but you can't lighten them. And put most of the detail on the mask of the face – the eyes, nose and mouth – since this is the focus of any portrait.

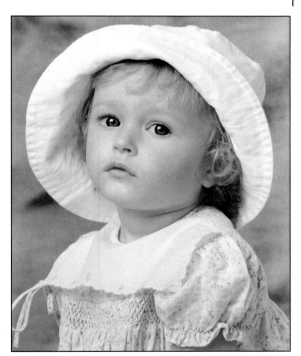

◀ **The set-up** Start with a large photograph of your model. This way you won't have to peer at the picture to make out the details.

Once painting a portrait in this way seems easy, start painting directly from life so you are constantly challenging yourself and moving on to more exciting things.

◀**1** Tape the tracing paper over the photo then measure out the most convenient divisions across the top and down the side. Our artist's photograph was 12 x 10in, so he marked off divisions in inches along each edge. Join up opposite marks to create a grid. Use a fine pencil and work carefully because accuracy is very important. You'll find it helps if you number the lines as our artist did.

▶ **2** For greatest accuracy, draw in the diagonals of the squares in which there are important or complicated features – the eyes, nose and mouth, for example. You might also want to do this for the ear lobe, say, or the angle of the shoulders.

Our artist also put in two vertical divisions to help him with the angle of the face, using a cross drawn at the base of the neck to place one vertical division accurately.

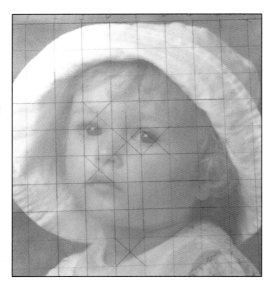

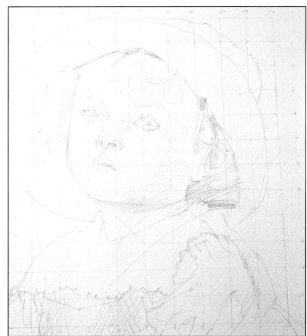

▲ **3** Lightly draw a grid of squares and diagonals on your paper, making them bigger than the ones on your photograph if you wish to enlarge the picture. Our artist made his 1⅛in square.

Now plot the contours of the face and indicate shadows with light pencil hatching. Use darker marks for the darkest tones, such as the line where the hat turns in.

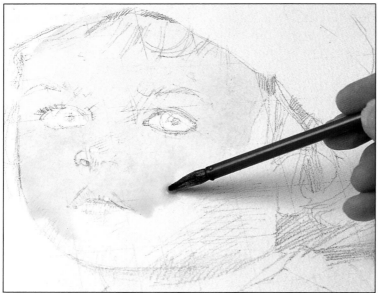

◀ **4** Before you start painting, rub out the grid lines where it is easy to do so. The fainter your lines have been, the easier it is to hide the remnants under the watercolour washes.

Mix up a very watery wash of cadmium orange with the Chinese brush. Paint it over the whole face, using a fully loaded brush so you don't get any brushmarks, and let it pool around the cheeks and forehead to start slight tonal variations.

▶ **5** Now mix a watery wash of French ultramarine and paint around the figure, again loading your brush. Start at the figure and work outwards to produce a faintly darker outline which helps to bring the figure forward. Leave the painting to dry naturally or use a hair dryer to speed things up.

With your paper laid flat to prevent runs, use a mix of raw sienna, yellow ochre and cadmium orange to shade the nose and the sides of the face where they go away from you. This helps to create a three-dimensional image. Leave the white of the paper to act as a highlight on the tip of the nose and chin.

Now use a dilute wash of cerulean blue to shade the hat, adding a touch of ultramarine for the darkest shadows. Indicate some of the colours on the dress, wet-on-dry, with pale pastel mixes.

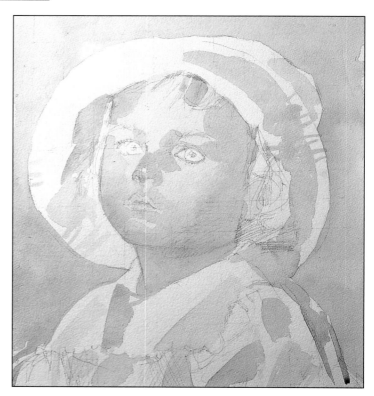

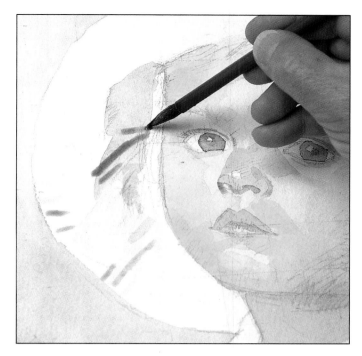

◀6 The eyes are an important focus, so paint in the irises and pupils with thin ultramarine and the No.3 brush, leaving small highlights as shown. Put in the lips with thin light red, following the curve of the mouth and leaving a highlight along the centre of the bottom lip. Add some burnt sienna to the wash to outline the top lip. This should blend into the lip colour. If not, go over it with a clean, wet brush to soften the tones.

Define the eyelids and nostrils with burnt sienna. Now darken the tones on the hat a little more with the Chinese brush and a stronger wash of cerulean blue and ultramarine.

▼7 Leave the picture to dry so you can judge the effect – dry colours look lighter than wet. The basic tones are in and already there is some three-dimensional modelling, but the hair is not in yet and the eyes and lips in particular need work.

For the bloom of Helen's skin lay thin washes which blend softly into each other. If you find yours look harsh, simply go over the edges with a clean, wet brush to blend them in slightly.

▼8 Mix yellow ochre and cadmium yellow to 'draw' in the hair, curling it naturally around the face and varying the tone by adding more water for a natural look. Now put in the creases on the neck with burnt sienna, using the No.3 sable round brush like a pencil to make strong, curved strokes. Use the same wash for the shadow where the dress curves round the neck.

Go over the line between the lips with light red, adding burnt sienna or Vandyke brown to darken it if you wish.

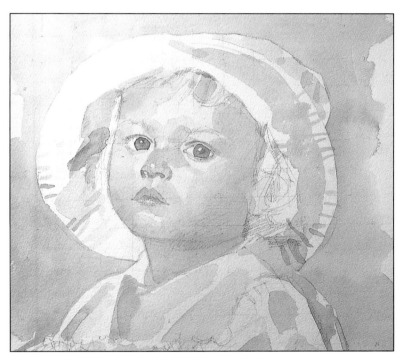

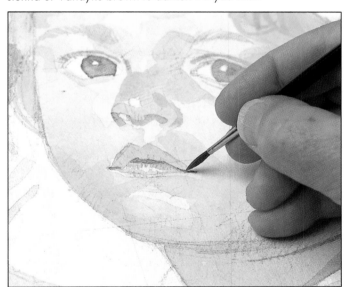

▶9 Mix a strong wash of ultramarine for the pupils and radial lines of the irises. Put these in with the tip of the round sable brush, taking care not to pick up too much paint or you may get blots. Vary the tone slightly, making sure you don't obliterate the highlight, otherwise the eyes will take on a blank appearance.

Outline the upper eyelids with burnt sienna, then use a more watery mix on the lower eyelids. Darken the shadows in the nostrils with light red. Now mix Vandyke brown and burnt umber to darken the upper eyelids and to stroke in each eyelash with the tip of the No.3 brush. Use the same mix for the darkest shadows under the hat, in the hair and the back of the neck.

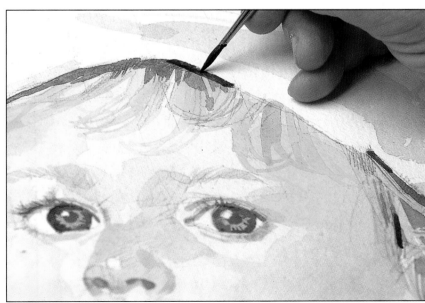

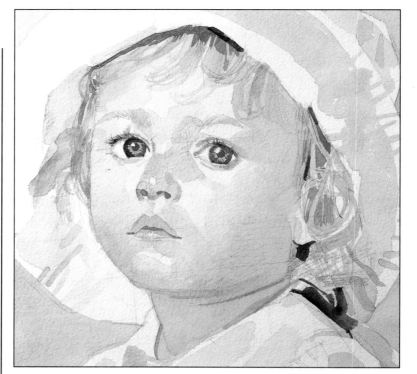

Tip

10 Leave the painting to dry, taking the opportunity for another overview. The dark brown shadows look stark at the moment, but when you darken the other tones these won't stand out so much.

Already the eyes have come to life, but our artist felt that the skin tones needed work – they should be warmed up. However, before you do this, wash a little dilute ultramarine over the whites of the eyes to shape them (see below).

11 Mix up a warm wash of light red and test it on the upper lip. Use the same wash to stroke in the creases on the lips. If you think the wash is about right for the cheeks, wash it over the child's right cheek and down the neck with your Chinese brush, then put some on the chin and left cheek. If it's a bit strong you can add some more water to thin it. Add other washes to shape the face as necessary.

Darken the light red mix with Vandyke brown and put in the darkest shadows of the nostrils. Finally, pull a watery version over the eyelids to warm them up a little.

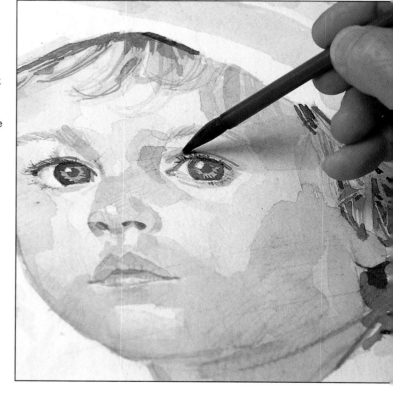

12 To balance the stronger colours on the child, you now need to strengthen the background. Use your Chinese brush and a strong wash of French ultramarine and Payne's gray for this, starting close to the figure and working outwards, as before. This should be a loose wash, leaving some of the first blue wash showing through.

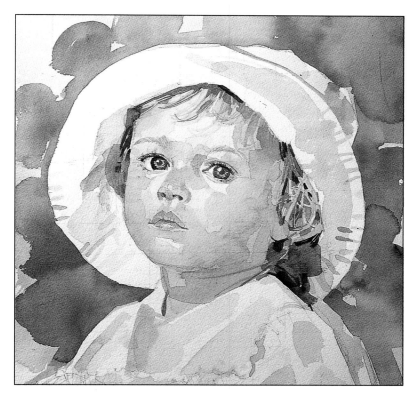

◄ **13** If the washes on the face have dried with hard edges, soften them by rubbing lightly with the clean, wet Chinese brush.

Apart from the dress, which needs elaboration, the basics of the picture are all in. From now on, you'll be putting in small touches of colour. These last touches can make or break a painting, so think carefully before each modification.

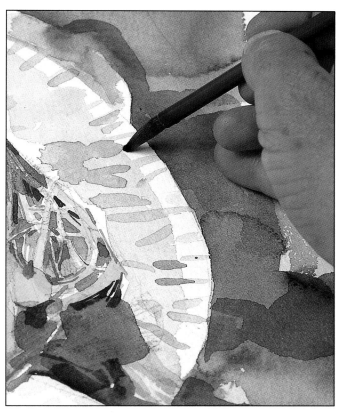

► **14** Start by indicating a few more creases on the hat with short dashes of your blue-grey wash, varying the wash by adding more colour for interest. These dashes balance the blue background and capture the way in which white fabrics reflect the colours round about. If the blues of the background are drying too light, add some of your darkest blue-grey mix to this too.

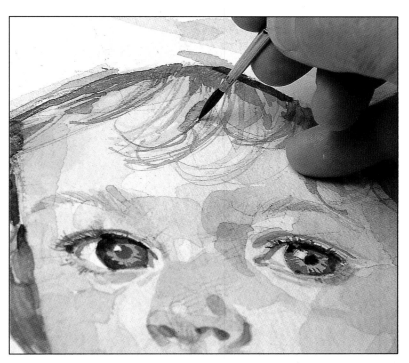

◄ **15** With your round brush, put a little light red under the upper eyelids on the left side of each eye to suggest shadow. This warm colour draws the viewer's attention to the eyes and makes the eyeballs seem to slip under the lids. If you like, add a stronger blue wash to the irises in places to give plenty of tonal variation and catch the viewer's attention even more.

Use the same brush to work on the hair with various brown and yellow mixes to suggest individual strands and the shadows behind and between them.

Tip

Warm draw
A good device in portrait painting is to choose a warm colour when you want to suggest something going in. Although you might expect to use a cool, receding colour to suggest a hollow, a warm colour can work better because it draws you in. Our artist used light red to 'push in' the nostrils and to suggest the gap between the lips, the curvature of the eyeballs and the hollows above the eyelids.

▶ **16** Too much detail on the dress will draw attention away from the face, but it's a pretty outfit so you can work on it a bit more. Indicate the floral pattern with a few spots of pastel colours and put the embroidery on the collar with a thinnish wash of cadmium yellow.

The smocking is clearest in the foreground where the pattern is highlighted by the shadow of collar and sleeve. Put this in with mixes of ultramarine, cadmium yellow and light red. Avoid the temptation to put in all the smocking – again this would detract from the face.

▼ **17** Compare the final portrait with the photograph. See how our artist has picked up the important details and dropped less significant items – he has emphasized the face, particularly the eyes, and played down the dress. He made the eyes fractionally wider apart and has altered Helen's expression slightly so that it is less apprehensive and more wistful. One of the advantages of a painting as opposed to a photograph is that you can do this.

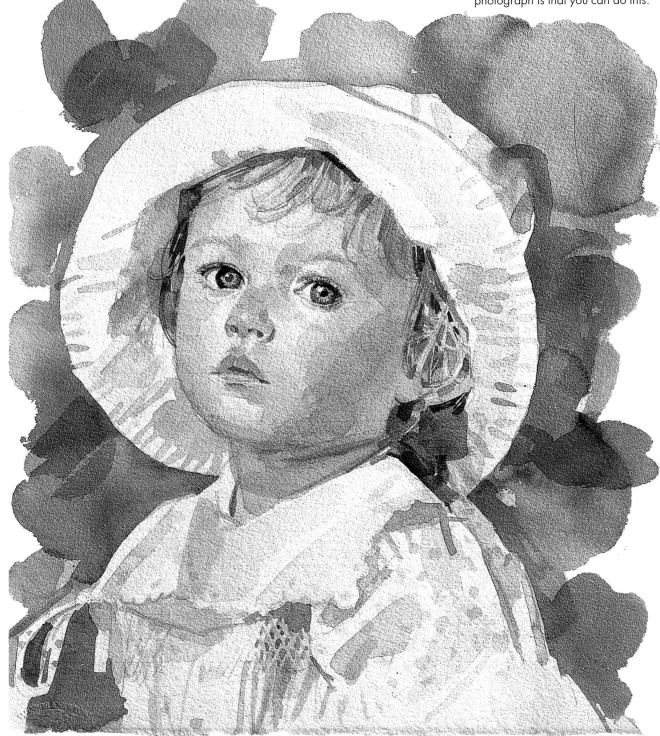

Mixed-media portrait

Fresh and expressive watercolour painting brings portraits to life, but for a really good likeness you may wish to underpin your picture with a solid drawing.

With portraiture, accuracy is vital, so an initial drawing is a valuable guide for a watercolour portrait. Pencil does perfectly well but for a strong impact try pastels, as our artist did for the portrait here. He chose hard pastels – Conté sticks (square pastels) – and pastel pencils in a traditional colour (sepia) for a classical look. The colour(s) you use will naturally influence the final result, so consider your selection carefully.

Once you've made your drawing, dust it down with a clean, dry rag (if you don't, the pastel pigment will run when you apply paint). The lovely trace this leaves will guide you as you paint. You may like to bring in your drawing media again – perhaps adding more colours to your palette – towards the end of the painting, when you're establishing the finer details.

Starting in this way, our artist drew the face finely. Watercolour washes allowed for a more painterly representation, but the strong three-dimensional quality of the painting owes much to a thorough groundwork of modelling, done in the early stages, when the shape and structure were established.

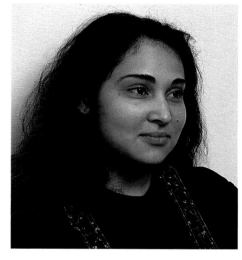

◄ **The set-up** Our artist asked the model to sit in a comfortable chair just a few feet in front of him. Her head tilts slightly towards the light coming in from the right, which catches her brow, cheek, nose and chin. Highlights like these help to bring out the roundness of the head. On her right, the model's head is shadowed, contrasting appealingly with the bright highlights. The amused smile in her eyes helps capture the viewer's attention.

◄ **1** Using the sepia Conté pastel stick, start by freely touching in the shape of the hair and head on the model's right side, keeping your marks light and delicate. Bear in mind that the head is basically egg-shaped. Gradually find its form by locating the shadows.

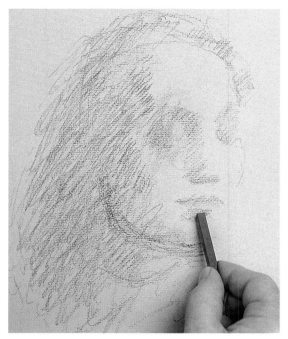

◄ **2** Place the features by indicating the shadows around the eyes, down the near side of the nose and under it, on the upper lip, under the lower lip and under the chin. Show the shadows on the side of the cheek and forehead and the angle of the jawbone.

Build up the shadows, making sure the eyes, nose and mouth are all facing the same direction.

YOU WILL NEED

- [] *An A3 sheet of sand coloured pastel paper*
- [] *Drawing board and bulldog clip*
- [] *Palette; dry rag*
- [] *Jars of water*
- [] *Two round brushes: Nos.4 and 6*
- [] *Six square Conté pastel sticks: white, cream, sepia, blue, green and dark brown*
- [] *Three Conté pastel pencils: white, sanguine and sepia*
- [] *Two Pierre Noire pencils: HB and 2B*
- [] *Six watercolours: yellow ochre, raw sienna, cadmium red, light red, Prussian blue and Payne's gray*
- [] *White gouache*

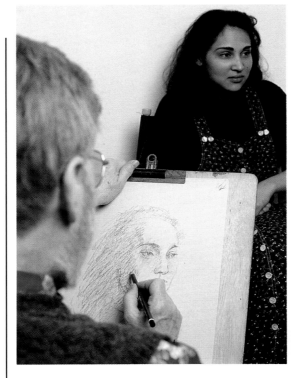

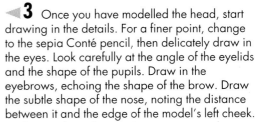

3 Once you have modelled the head, start drawing in the details. For a finer point, change to the sepia Conté pencil, then delicately draw in the eyes. Look carefully at the angle of the eyelids and the shape of the pupils. Draw in the eyebrows, echoing the shape of the brow. Draw the subtle shape of the nose, noting the distance between it and the edge of the model's left cheek.

As you draw the mouth try to capture the movement around the lips. There is a slight smile, so the tiny shadows in and around it are very important.

(Make sure you are positioned so that you can see your model clearly, and are sitting comfortably. Our artist prefers to hold his drawing board up, resting it on his knees, with the paper held securely by a large bulldog clip.)

4 Strengthen the modelling of the cheekbone and position the ear (the base of the lobe is usually level with the nostril). Check the height and shape of the hair – this is often higher than you would expect. Very carefully draw the shadowy line around the jaw, bring out the chin and place the model's left shoulder.

Sharpen the point of the pencil (see Tip) to put in the fine hairs along the hairline on the forehead, describing the directions in which they are growing. Now deepen the shadow between the hair and cheek, moving down to the neck.

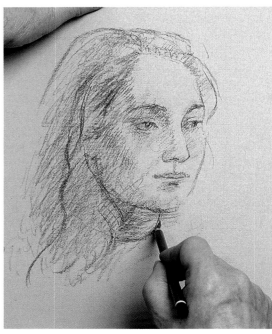

5 Once you've finished drawing, step back and take a look at the results. Have you got the correct proportions and angles? Correct your drawing where necessary.

Then, using a dry rag, flick back your marks, removing the powdery top layer until only the more confident marks remain (far right). With this trace as a guide, you can work over your drawing in watercolour without the pastel pigment blending into the paint. The classical colour of the pencil modifies the colours to come and gives a warm glow to the painting.

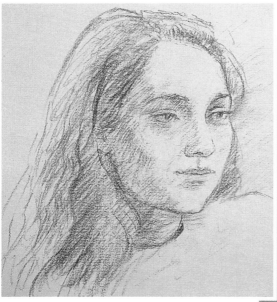

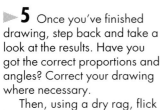

◄ **6** Mix Payne's gray watercolour and a touch of raw sienna and use the tip of the No.4 round brush to paint the edge of the eyelids with fine lines, thickening them at the corners to suggest eyelashes.

Very delicately draw around the eyes – the top of the upper lids, the bottom rim and beneath the lower lids – with a mix of raw sienna and a little cadmium red. Use light red and then Prussian blue to paint the pupils, leaving spots of pale paper showing through for the highlights.

Tip

Sharpen up
You need a sharp point on your Conté pencil for the details. Try holding it flat against a piece of fine grade sandpaper and rubbing gently.

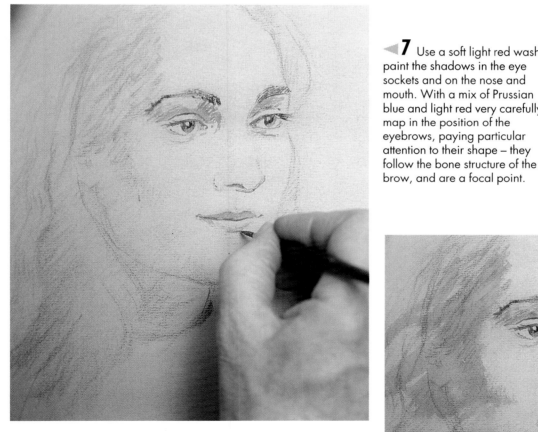

◄ **7** Use a soft light red wash to paint the shadows in the eye sockets and on the nose and mouth. With a mix of Prussian blue and light red very carefully map in the position of the eyebrows, paying particular attention to their shape – they follow the bone structure of the brow, and are a focal point.

► **8** For the big shadow down the right side of the model's face, use the No.6 brush and a very watery wash of light red and raw sienna, spreading the colour around loosely.

▶ **9** Dilute the same wash further for the soft shadow down the near side of the nose. Then paint the hair. Use your mix of Prussian blue and light red for the darkest strands in the shadow, framing the model's cheek with big, free-flowing brushstrokes.

▽ **10** Add more light red to lighten the previous mix. Water it down and paint in the full head of hair, looking again at its loose outline and carefully framing the left side of the model's face down to the shoulder.

▶ **11** Using mainly yellow ochre with touches of raw sienna and Payne's gray, put a quick wash over the whole face, keeping it stronger on the shadowy near side and slightly thinner on the far side. Then wash the colour out of the brush and, using the brush slightly wet, lift off areas of paint for the highlights on the forehead, cheek, nose and so on.

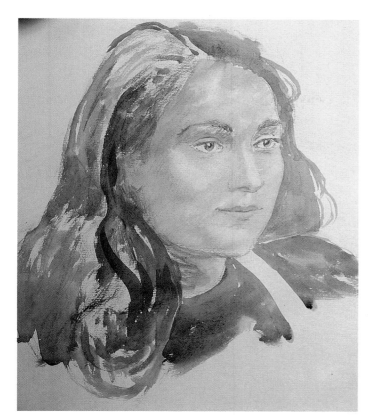

◄12 Darken the wash you used for the shadows in the hair with Payne's gray and use this colour to put in the model's T-shirt, cutting around the shape of the dress strap.

►13 Rework the structure of the face with the sepia pencil. With light strokes build up the darkest shadows around the brow, cheeks and jaw, and bring out the different planes around the eyes.

Sharpen the point of the HB Pierre Noire pencil and delicately pick out the shadows under the nose and the fine shadow between the lips. Change to the sanguine pencil and add the tiny shadows around the eyes and on the upper lip. Then define the bridge of the nose.

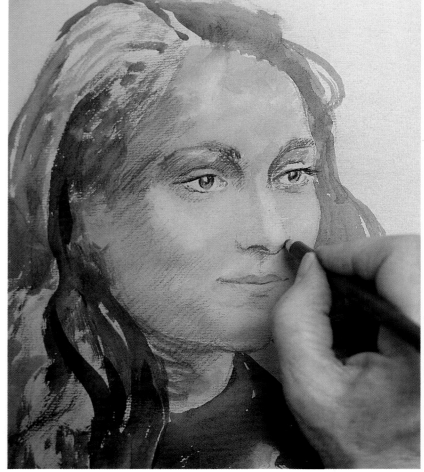

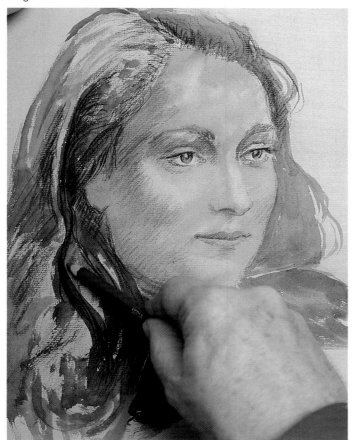

◄14 Once the paint has dried on the hair, adjust the shadows using heavy pressure on the sepia pencil. Catch the rhythm and fullness of the strands with flowing lines, layering them in deep behind the cheek.

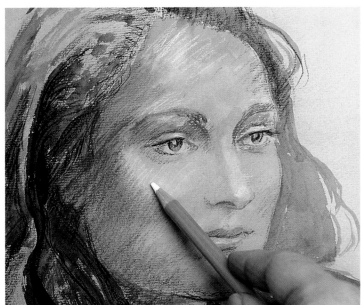

◄15 To complete the modelling of the face, use the sharp white Conté pencil and, with the finest, most delicate lines, add the highlights on the brow, eyelids, cheek bone, the tip of the nose, above the upper lip and just a spot or two on the bottom lip.

To add more subtle colour into the shadows use the green pastel stick and gently work it in around the temple, cheek, jaw and neck. Add a little cream and dark brown around the chin too.

►16 Mix plum with Prussian blue and light red and make the hair thicker with loose strokes. Deepen the colour of the hairline and the strands on the far side, and strengthen the brows to achieve a rich hue. Paint the dress strap using a Prussian blue/white mix.

Rough in the background with the white Conté stick. This brings the head forward. Add blue to the left to indicate a shadow. With a touch of white gouache pick out the lower rims and corners of the eyes. Add a soft wash of light red/Payne's gray around the eyes, under the nose and mouth. Work over the hair with the sepia Conté pencil and the Pierre Noire 2B, blending in any lines that are too strong and stripy, softly modelling the individual locks and adding loose wisps around the edges.

The finished portrait successfully combines various media – drawing on the accuracy of pencil and the soft tones of watercolour.

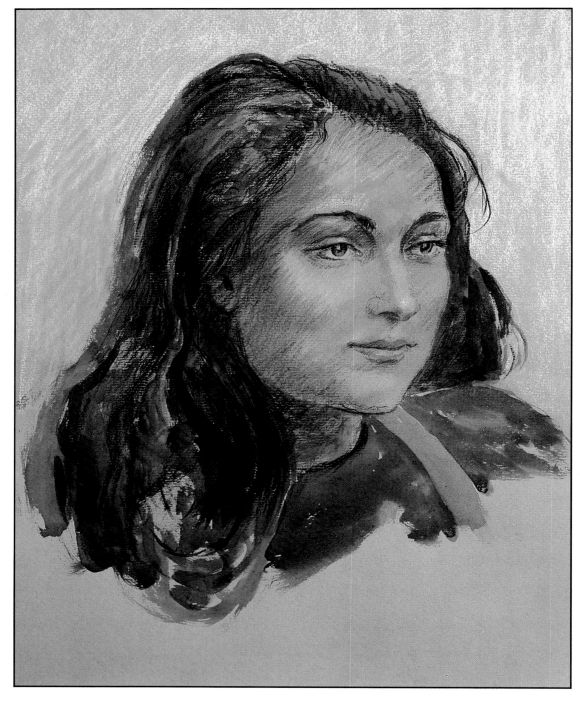

EXPERIMENT WITH UNUSUAL GOUACHE EFFECTS

Mixing water-based media

By uniting the effects of gouache and water-soluble pencils – in effect making use of both your drawing and painting skills – you can create your own interpretation of this stunning bouquet of roses.

No two artists would approach these roses seen against an exuberant floral backcloth in quite the same way. Here the artist has rejected a bold and vigorous approach in favour of a more subtle treatment which focuses on the delicacy of the flowers and the wonderful, swirling, spiralling arrangement of their bunched petals.

To achieve this she uses thin washes of gouache to establish the main areas of tone and colour, leaving large areas of the paper showing through to give the image lightness and clarity. The water-soluble pencils give her a combination of washes and crisp lines. The calligraphic pencil marks give the final image a highly decorative quality.

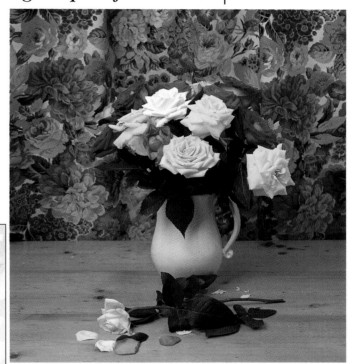

▲ **The set-up** This voluptuous arrangement of fresh garden roses makes a lovely subject for a mixed media picture. The printed flower fabric complements the roses without interfering too much with their bold colours, while the plain white vase almost steps back to allow the roses to take centre stage.

◀**1** Lightly draw the outlines of the vase, roses and leaves with the yellow ochre pencil. Suggest the petal edges and the folds in the background fabric. Then wash in the table with dilute yellow ochre gouache, using the No.12 brush and painting around the rose and the petals lying on the table.

Mix a little alizarin crimson into your wash and use this new colour to paint some of the printed flowers on the fabric, blobbing them in with the side of your brush. Don't try to render the fabric pattern exactly – aim for an approximate impression. Dilute the wash with water to soften the pencil lines of the fabric folds.

YOU WILL NEED

- [] *An 18 x 24in sheet of 140lb NOT watercolour paper*
- [] *Two synthetic brushes: a No.12 round and a 10mm flat*
- [] *Palette; jars of water*
- [] *Nine water-soluble coloured pencils: two Caran d'Ache (or equivalent) – yellow ochre, violet; seven Rexel Derwent (or equivalent) – sap green (49), mineral green (45), bottle green (43), deep cadmium yellow (6), madder carmine (19), geranium lake (15), spectrum orange (11)*
- [] *Eight gouache colours: six Winsor & Newton – alizarin crimson, cerulean blue, cadmium red deep, yellow ochre, fluorescent magenta, orange lake light; two Linel (Lefranc & Bourgeois, or equivalent) – light green deep and Persian yellow middle*

▶ 2 Continue building up the flowers on the fabric with more blobs, then paint some of the background areas of fabric with dilute yellow ochre – the idea is to cover most of the white of the paper. Add plenty of water and a little more yellow ochre to your alizarin/ochre mix and apply this very dilute wash to the white and yellow roses in the vase.

◀ 3 Use a clean, wet brush to stroke colour from the violet pencil on to the palette. Mix this with cerulean blue gouache to make mauve, and use it to blob more flowers on the fabric, adding leaves with dilute light green deep. Allow the colours to overlap – as you apply these two washes over wet paint, they blend to create new colours.

If you feel your hues are a little too washed out, work around the painting, strengthening them.

Accentuate a few fabric folds with your flat brush and some alizarin crimson.

▶ 4 Paint loose outlines for the yellow roses with the flat brush and a pale wash of Persian yellow middle. When this has dried, add more Persian yellow middle for a stronger tone and fill in the petals further. If you wish, you can modify the wash again and repeat the process to give a series of subtle tones. Apply some of the wash to areas of the table to vary the tones there.

Mix cadmium red deep, fluorescent magenta and alizarin crimson to paint the red roses in the same way. Vary the amount of each colour in the wash to create slightly different hues. Once you've washed in the pale tones, draw the petal edges with a stronger wash, using the flat edge of the brush and trying to make them look as though they are curling over. Paint the peach-coloured rose at the front with very pale orange lake light.

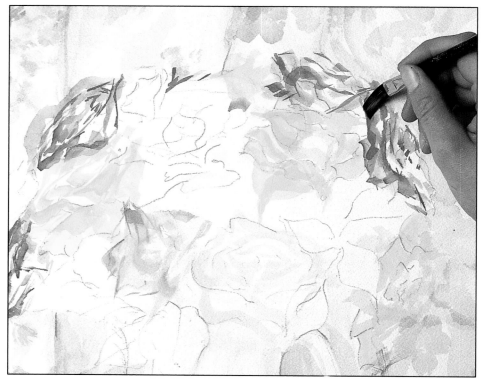

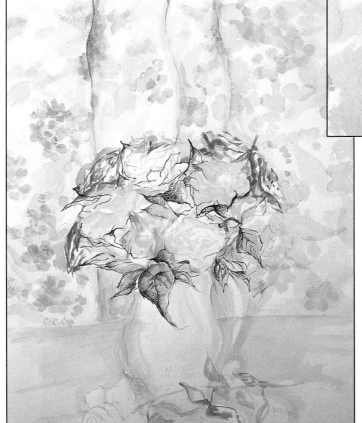

5 Paint the leaves around the bouquet with dilute light green deep. Again, vary the shade, adding either more paint or water for different tones. Notice how the addition of the leaves helps define the edges of the flowers. Remember, you don't have to put in all the leaves – select important ones to include and leave out others.

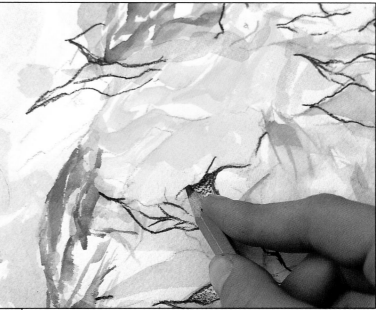

6 When the leaves have dried, add detail with the sap green pencil. Draw the outlines and veins, then use the side of the pencil to put in some dark tones. You don't have to keep strictly to the painted leaves – our artist drew in leaves where she hadn't painted them, sometimes going over parts of the petals.

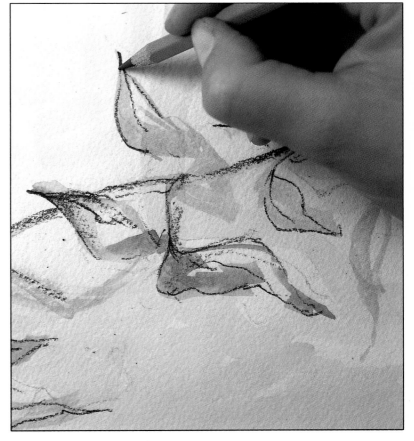

7 Carry on working into the leaves with sap green. Use the same pencil to outline a few petals on some of the lighter roses. It doesn't matter that this colour isn't true to life – its darker tone helps to differentiate between the petals. Do the same with the petals of the white rose lying on the table.

8 Work into the leaves again, this time with the mineral green pencil. Start with the leaves of the foreground rose. Notice how the green paint and pencil marks work together as different tones. This helps to make the leaves more convincing.

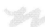

9 Draw into the petals of the yellow roses with the deep cadmium yellow pencil to strengthen them. Use the side of the pencil as well as the point, and apply different amounts of pressure for a variety of colour intensities.

Stay with the same pencil for the loose yellow petals on the table. Use the pencil on areas of the jug and table too, blending in the colour with your brush and clean water.

Work into the red roses in the same way, using the geranium lake and madder carmine pencils. When you're drawing the petal edges, apply more pressure on the pencil for darker, crisper lines.

10 Use the flat brush to give body to the vase with the mauve wash you used for the fabric flowers. Apply the spectrum orange pencil to correct and reinforce the outline of the vase and draw in the handle. Soften some of these lines with clean water and the flat brush.

Draw the edge of the table with the yellow ochre pencil, then give the vase some darker tones and work into the table itself to indicate its grain. Blend in these marks with clean water. You can soften them further by rubbing them down gently with kitchen paper/paper towels.

11 Now outline more of the petals on all the flowers with the red and green pencils – this colour variation adds interest. Use spectrum orange for the peach-coloured rose petals.

Add the finishing touches. Paint the foreground petals with fluorescent magenta, and strengthen the leaves around the edge of the bouquet with the bottle green pencil.

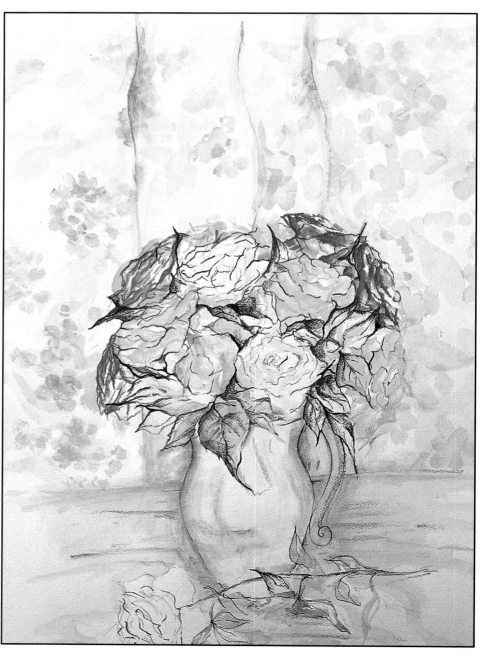

Wash-off with gouache & ink

Wash-off is a technique that combines gouache and waterproof ink to produce pictures with a great sense of drama and immediacy.

To do a wash-off you must first make a painting in gouache, then completely cover it with a layer of waterproof ink before flooding the paper with warm water. This washes off some of the water-soluble paint and the ink that covers it, but it leaves the ink in the unpainted areas untouched.

The result is a picture full of drama, with striking areas of solid black ink. But remember, wash-off is not precise: some of the ink adheres randomly to the painted areas. However, this is part of the charm of the process – the remnants of ink help to enliven the surface. In fact, they make the painting look rather like a woodcut.

There are undoubtedly some heart-stopping moments in doing a wash-off, especially when you completely obliterate your gouache painting with black ink. But if you follow a few simple guidelines, there is nothing to worry about.

First, since the paper comes in for quite a battering at the wash-off stage, you must work on a heavyweight paper (about 300lb), stretched on to a board with gum strip. If the gum strip loosens towards the end of the wash-off, take some fresh strips and re-stretch the paper.

When you start your picture with gouache, make sure you apply the paint thickly – otherwise the water will not be able to lift the ink and you'll end up with a black painting. Note that in general the colours that remain after the wash-off are the ones you put down first. Use artist's quality paints since cheaper paints have a poor staining quality and may leave a very faint image.

Make sure your gouache painting is totally dry before covering it with black waterproof ink. And likewise ensure the ink is dry before attempting the wash-off. A hair dryer can be handy here.

When you are ready to wash off the ink, start with lukewarm water. Hot water lifts the paint rapidly, often uncontrollably, while cold water works very slowly, if at all. Gradually add more warm water as you become accustomed to the process.

The most important tip, though, is to plan your picture carefully before you start. This type of image does not lend itself to an intuitive approach. Think about which areas you want to appear as black and leave them as unpainted paper. Remember also that the areas you want white have to be painted white.

▼ The wash-off technique can be used to create some dramatic images. Here, the black ink arch and traces of ink among the areas of colour give intensity to this striking Venice scene.
'View of St. Mark's Square' by Kate Gwynn, gouache and black waterproof ink on paper, 10 x 7½in

View of the Grand Canal, Venice

The great advantage of a wash-off is that your initial painting does not have to be over-elaborate. Our artist made sure she simplified the very detailed reference photo (below). The water, for instance, is rendered in rather crude, broad brushstrokes. This resulted in the ink clinging between the brushstrokes, helping to create a very lively area of the painting.

YOU WILL NEED

- [] *A 19 x 14in sheet of stretched 300lb NOT watercolour paper*
- [] *2B pencil*
- [] *Two brushes: a No.4 round and a ½in flat*
- [] *A palette*
- [] *Two jars of water*
- [] *Cotton balls; sponge or soft, clean cloths*
- [] *Two clean jugs or containers – one for hot and one for cold water for washing off the black ink*
- [] *Jar of waterproof Indian ink*
- [] *Eleven gouache colours: titanium white, cadmium yellow, yellow ochre, Venetian red, spectrum red, cerulean blue, Winsor blue, oxide of chromium, emerald green, raw umber, burnt umber*

▶ **The set-up** Our artist took several photos and made a reference drawing for her painting of the Grand Canal in Venice. She chose a viewpoint that led across the colourful gondolas to the Rialto bridge. The mooring posts lead the eye into the composition.

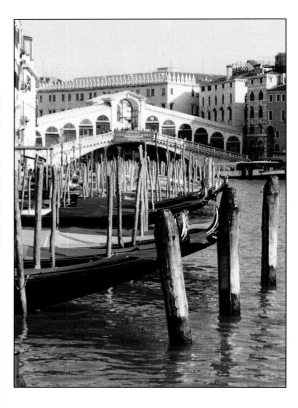

◀ **1** Draw the outlines of your painting in pencil, putting in all the details you want for the final image. Don't over-elaborate, though, as you'll be working with very thick paint.

◀ **2** Start blocking in the sky with mixes of Winsor blue, titanium white and raw umber. The paint should be thicker than for a normal gouache painting. You can build up several layers, but note that many of the layers may be washed away.

Start on the buildings by painting the red façade in Venetian red. Add titanium white to paint the lighter building to its right. Dull this mix to a grey with oxide of chromium and white for the grey buildings. Paint the surrounds of the windows in titanium white. The windows themselves are left untouched so that the Indian ink will stain them black.

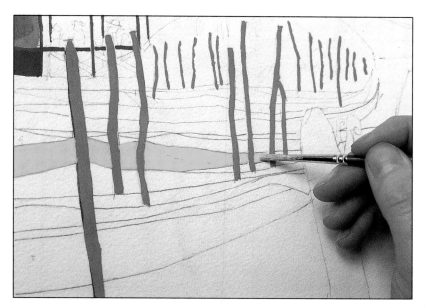

◀ **3** Paint the mooring posts in yellow ochre and the cover on one of the gondolas in cadmium yellow. Use blues, emerald green and red to paint the rest of these covers. Remember to apply the paint thickly – the surface of the paint should be noticeably raised above the paper. Leave the hulls of the gondolas blank – these will be coloured by the black ink.

▼ **4** Paint the bridge with titanium white, adding touches of emerald green, cerulean and burnt umber. Paint the bridge windows green and the banner red, then work on the buildings. Turn the picture upside down to do the more awkward details of the architecture near the skyline.

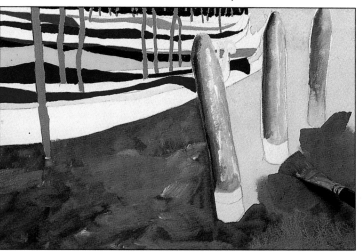

▲ **5** Work on the large mooring posts in mixes of burnt umber, raw umber, white and touches of cerulean. Leave the tarred bottom of the posts to be filled in with black ink. Start on the water with the ½in flat, using cerulean blue as the base colour. Add oxide of chromium and raw umber and fill in the rest of the water with very free brushstrokes.

▶ **6** Add a few touches of neat titanium white to the foreground to create the impression of foaming water. Black ink will cling in between the brushstrokes, adding drama to this area of the picture. Now wait until the painting is completely dry before you continue.

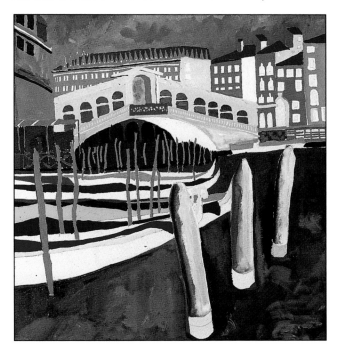

Tip

Start small
Before attempting anything too ambitious, familiarize yourself with the wash-off process on a simple small-scale subject, such as a stained-glass window. Remember, it's impossible to do anything too complicated since you can't capture intricate details with the thickness of paint needed. Our demonstration is just about as detailed as is practical.

7 Lightly brush on the Indian ink with the ½in flat brush so that it just covers the gouache. Make sure you don't disturb the paint. You should be able to see the raised surface of the paint through the ink, and the dips in the surface where the paper has been left untouched. Once the whole picture is covered, allow the ink to dry. (To speed up the drying, use a hair dryer).

8 Now hold the picture over a sink or bath and gently pour water over it. Pour close to the picture so that you don't disturb the paint surface with splashes. Start with luke warm water and gradually add more hot water as you become familiar with the process.

9 Turn the board round from time to time so that the water is not constantly flowing in one direction. Start from the centre of the picture and work towards the edges, turning the board as you go. Use the temperature of the water to control the speed at which the ink lifts off.

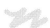

10 To loosen ink that is caked on, gently coax it away with a sponge or cloth. Remember, you don't have to clean all the ink away. Traces of ink among areas of colour and ragged edges are all part of the beauty of the technique. If you were attempting to obtain flat washes of colour with straight edges, there would be no point in flooding the picture with ink at all.

11 In the last stages, carefully wash off the debris with cold water. Don't pour too much water over the gondola covers since the colours here should remain strong and vibrant. Try not to be too fussy and eliminate every piece of ink from areas of colour – instead let it dry, consider it and make any adjustments at a later stage.

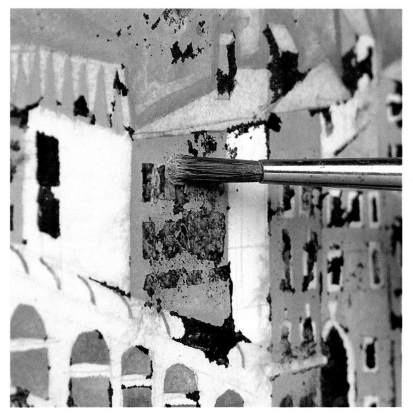

12 Use a clean brush or a cotton ball dipped in hot water to clarify necessary details where the ink hasn't lifted off. Remove really stubborn marks with your fingernail and wash off the area with cold water.

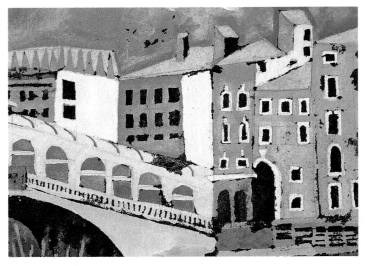

▲13 In the final picture, colour has been washed from the façades of the building, helping them to recede into the distance. Traces of ink remain on these facades to create a sense of immediacy and freshness.

▲14 Our artist took care not to wash the colours from the gondola covers. Together with the opaque black of the ink, it provides a striking focal area in the picture.

▶15 As a final touch, our artist added the white reflections of the mooring posts.
 The final picture is an interesting mix of styles. The gondola covers provide a bright, eye-catching area of colour, but the wash-off has created muted hues that capture the cloudy sky, the murky river and the faded façades of the architecture. Note, finally, how the viewer's eye is also drawn directly to the white bridge.

Gouache and gum arabic

The opaque 'body' of gouache paint demands that you use it rather differently from watercolours. Mixing gouache with gum arabic creates a slight gloss and extra texture.

Gouache is simply watercolour to which white chalk has been added. The paint gains in body and opacity, so you can work light over dark and dark over light in a way that is more akin to oil painting than working with watercolours.

Gouache paint leaves a flat matt surface and is very fast drying, making it ideal for *alla prima* work. But mixing it with gum arabic slows down the drying process, allowing you to manipulate the paint on the surface longer – again, rather like oils.

In the demonstration overleaf, our artist added gum arabic to her gouache paint in increasing quantities as the picture progressed. Laid over dry areas, it enhances the texture and adds surface gloss. Her choice of subject was highly suitable for her technique: the geranium leaves and flowers had a sheen that needed the help of gum, while the earthy matt combinations in the terracotta flowerpots and wooden fencing backdrop could be rendered in gouache alone. Working up the surface quickly to cover as much of the white paper as possible, our artist rapidly applied the paint over a detailed drawing, remixing colours intuitively and allowing the painting to evolve rather than following a methodical plan.

► **This composition demonstrates to the full the virtues of mixing gouache with gum arabic – adding colour intensity to the geranium blooms and a deeper sheen to the leaves. Spatterings of gouache and gum create a more lustrous and variegated background, making the display stand out still further.**
'Tub of potted geraniums' by Carolyne Moran, gouache and gum arabic on paper, 8½ x 12½in

Potted red geraniums

YOU WILL NEED

☐ An A3 sheet of Bockingford 250gsm watercolour paper

☐ Palettes and jars of water

☐ One HB pencil

☐ Four round brushes: Nos. 1, 2, 4 and 8

☐ Gum arabic

☐ Ten Winsor & Newton gouache paints: permanent white, spectrum yellow, spectrum red, alizarin crimson, cadmium red pale, alizarin rose madder, magenta, ultramarine, raw umber and jet black

▼ Our artist makes a policy of keeping her warm and cool colours separate on her palette. Try to do the same — it will save time and effort in the mixing process.

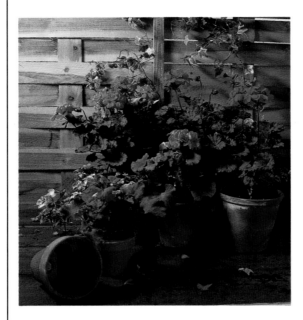

◀ **The set-up** Our artist liked the contrast between the circular pots and plants and the strong verticals and horizontals of the background fencing. The empty foreground pot, lying on its side, was placed to lead the eye up to the main clump of pots.

Before deciding on the final set-up, our artist spent some time examining the still life from different angles through a cardboard viewfinder. A viewfinder allows you to see the composition as it will appear in the final painting, and make adjustments accordingly.

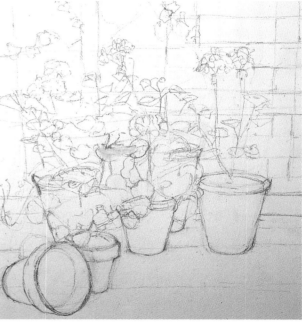

▶ **1** Plot the composition with the HB pencil. Make sure the ellipses of the flowerpots are accurate – you don't want to start readjusting these at an advanced stage of painting. However, don't trouble to sketch in every leaf and flower – you will render these later with some free, impressionistic brushwork. Make the pencil outlines as dark and pronounced as you wish – they will eventually be covered by the opaque paint.

▶ **2** Lay out your palette with ultramarine, spectrum yellow, spectrum red, alizarin crimson, raw umber and white. Add a drop of gum arabic to your water to help the paint flow.

Mix the paint in small amounts, adding water until you have a colour which roughly matches the foreground floorboards. Block in the base of the composition with the No.8 brush. Adopt a free approach, remixing the colours as you work to vary tones and indicate shadows. Use the same mixes to put colour on the flowerpots.

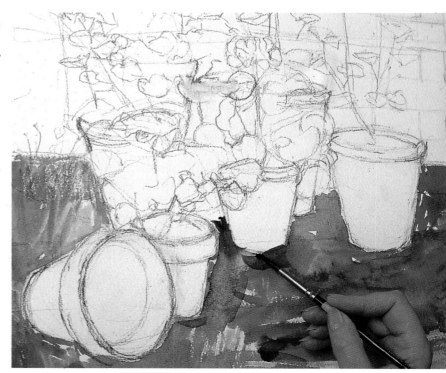

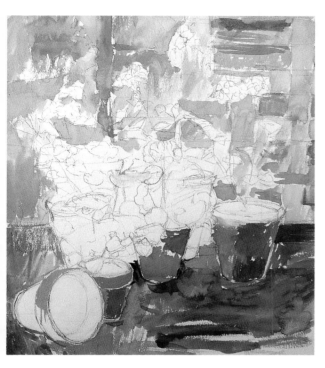

3 Now begin working on the background fence. Mix crimson, yellow and white, and paint loosely around the geranium blooms. Keep the paint watery and work wet-in-wet, varying the tones and brushstrokes to create texture and interesting wash effects.

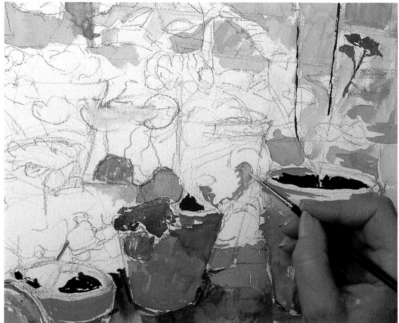

4 Mix rich browns from cadmium red pale, black and ultramarine and, with the No.2 brush, build up the flowerpots. Paint the earth in the pots using a mix of jet black and gum arabic. In general, lay the paint down in flat, solid washes. Use the same brush and a mix of ultramarine, spectrum yellow and gum arabic to render the foliage.

5 Paint the petals of the geraniums with a mix of magenta, spectrum red and white loaded on the No.4 brush. Use cadmium red pale for the brighter red blooms.

Paint shadowed areas of foliage with a cool grey mixed from ultramarine and spectrum yellow.

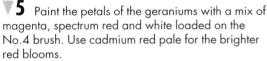

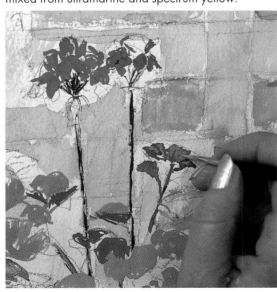

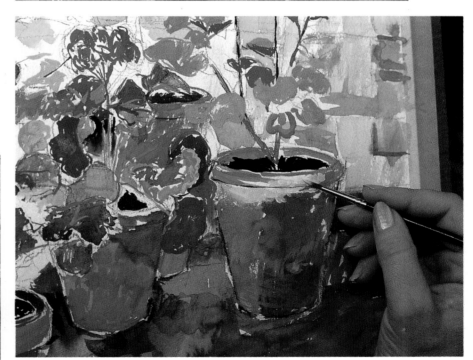

6 Paint the limescale deposits on the pots with a weak white solution. This adds form to the flowerpots. Using brown mixed from black, ultramarine and spectrum red, and a variety of brushes and brushstrokes, recreate the rough and/or glazed texture of the earthenware pots.

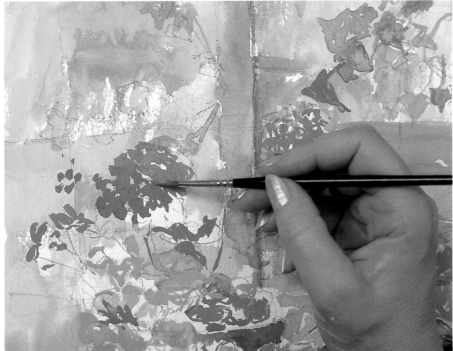

◄7 Add alizarin rose madder to your palette and remix the pinks to provide another hue for the geranium blooms.

Work around the painting with mixes of raw umber and spectrum yellow, building up the shapes of the earthenware; use generous swathes of this colour to render the criss-cross pattern of the background fencing. Use the cool grey mix and variants of the blue/yellow mix to build up the foliage.

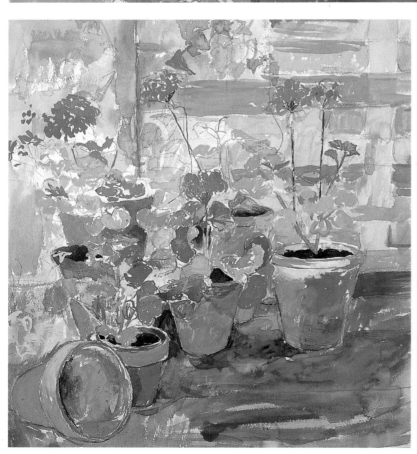

▲8 Most of the composition is now blocked in. Stand back from the painting and consider what needs to be done next. The first thing that struck our artist was that the pots lacked form – shadows need to be painted in or emphasized.

▲9 Mix alizarin crimson, spectrum red, jet black and ultramarine and, using the No.4 brush, scumble the curved shadow inside the left foreground pot. The scumbling or drybrush technique is ideal for rendering the rough texture of dirty, unglazed earthenware.

◀10 Look carefully at the way light affects the colours of the individual geranium leaves. Continually mix and remix combinations of ultramarine, spectrum yellow and gum arabic, and begin to lay down a variety of green tones over them. Add tinges of other colours for greater variation.

For example, describe the outer edge of a leaf (inset, top) using a thick solution mixed from ultramarine and yellow. Create the look of mottling on the leaves (inset, bottom) by adding a little red to the green mixture and painting quite wet-in-wet.

▼11 Build up the picture surface using a variety of painting techniques to maintain the vitality of the image. Lay lights over darks and vice versa. Merge colours into one another by painting wet-in-wet, and use drybrush techniques and drawn lines to redefine the terracotta pots and the irregular, curly-edged geranium leaves.

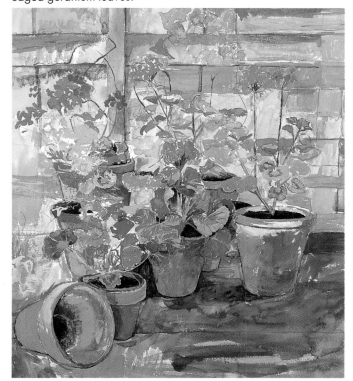

▲12 Mix ultramarine and spectrum yellow and, with the No. 2 brush, draw a 'filigree' outline around the leaves of the trailing vine. Use a lighter green for the vine leaves in the bottom left corner.

13 Make the blooms still more brilliant by adding gum arabic to various shades of pink, alizarin crimson and spectrum red and applying these mixes liberally.

Paint globules of pure gum directly on to the dry picture surface – this will create extra 'glisten' and make the blooms stand out still further against the geranium leaves.

14 Using the No.4 brush, a thin solution of spectrum red and umber, and free, fluid movements of your hand, darken the shadows of the flowerpots in the foreground.

15 The painting is now nearly finished. Stroke in a few more flower stems using the No.1 brush and a mixture of jet black and raw umber. Add a few final touches to the background wall with raw umber and spectrum yellow.

You can see that the result of all your hard work is a painting which, though detailed, maintains a fresh, free quality – created largely by the careful addition of gum arabic to enliven the naturally matt texture of gouache and provide glossy highlights.

Using gouache on tinted paper

There's a long tradition of using tinted paper with gouache. Applying the opaque paint in thin washes allows the paper colour to show through in places, adding warmth or coolness to your work.

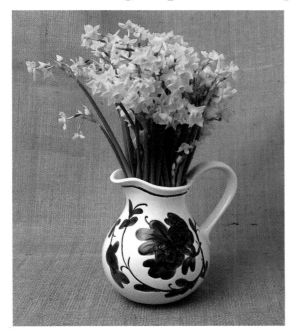

Since gouache is opaque, it has excellent covering power, enabling you to work from dark to light if you wish. Many artists commonly paint on coloured paper or on white paper tinted with watercolour or acrylic. Obviously if you ladle the paint on, gouache will cover up everything. But used fairly thinly, it allows the mid-toned ground to show through underneath.

Beige, yellow ochre, pale green and even light grey are suitable mid-tone colours to use. There are many more options available. Don't just pick a paper colour at random – choose one to suit the mood or colour composition of your painting. If you're working on a dull winter landscape, for instance, try using a light grey paper. Allow the paint to build up in some areas, but let the paper show through in others.

◀ **The set-up** These small, bright flowers are challenging to capture in the opaque colours of gouache. The hand-painted glazed jug has a smooth, round surface which contrasts with the asymmetrical flowers. The background is a piece of natural hessian, not unlike the beige tinted paper our artist chose.

YOU WILL NEED

- [] A 14 x 20in sheet of stretched beige-tinted 140lb NOT watercolour paper
- [] A 2B pencil
- [] Three round sable/synthetic brushes – Nos.4, 5 and 12
- [] Two jars of water
- [] One or two palettes
- [] A clean cotton cloth
- [] Thirteen gouache colours – primary yellow, spectrum yellow, golden yellow, lemon yellow, yellow ochre, permanent light green, Winsor green, scarlet lake, cadmium red, cobalt blue pale, permanent white, cool grey No.5 and warm grey No.5

▼ **1** Use the 2B pencil to draw the jug and mass of flowers on the paper. Roughly indicate the line separating foreground from background.

Make a loose wash with permanent white and paint in the jug with the No.12 brush. While this is wet, add some warm grey No.5 mixed with a little cobalt blue pale to darken the bottom and side.

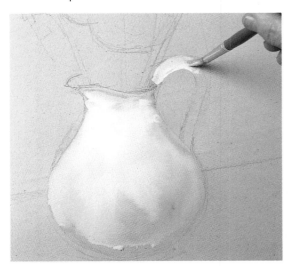

◀ **2** Mix some permanent light green and Winsor green, and form the stems rising from the jug with the No.12 brush. Map out the foreground in yellow ochre. Add a little white to yellow ochre for variety. Allow the colour of the paper to show through here and there.

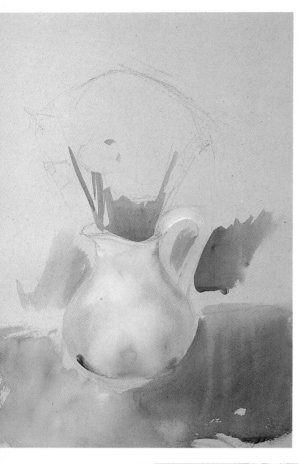

3 Add a little warm grey No.5 to some yellow ochre to darken it. Continue working on the foreground and background with the same brush, interplaying light and dark areas.

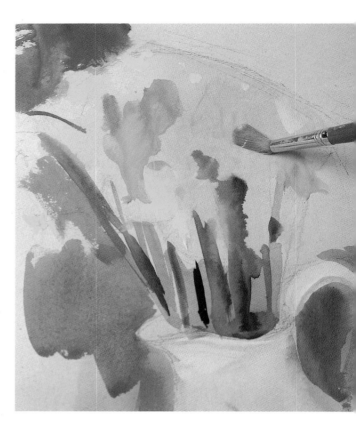

4 Mix Winsor green with a touch of warm grey No.5, and create more green tones on the stems with the No.12 brush.

Use the same brush to block in the general area of the flowers with a mix of primary yellow and golden yellow. The colour isn't painted on uniformly – our artist has made some dark, impasto-like marks and allowed areas of the paper to show through for variety.

Mix cobalt blue pale, warm grey No.5 and dilute white and darken part of the handle.

5 Still with the same mix, darken the base of the jug. Use some dilute white to highlight the side of the jug, blending it with the No.12 brush. Let the paint flow freely; you can add detail later on. Don't panic if the paint runs – it's easy to correct at this stage of the painting.

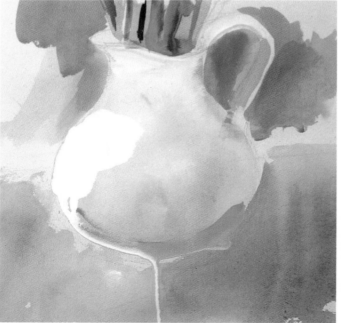

6 Return to the background. Mix yellow ochre with warm grey No.5, and paint in some areas at random. Add white to the mix to lighten it and apply to other areas to vary the background tone. Paint around the bunch of flowers – don't be afraid to redefine the shape if you wish. For the shadow areas on the right side of the jug, use a mix of yellow ochre, white and cobalt blue.

Darken the rim of the jug with a little Winsor green mixed with cobalt blue pale and cool grey No.5. Vary the greens within the flower stems with a mix of Winsor green and permanent light green. Now adjust the tones of the jug as needs be. Leave to dry.

7 Add another layer of paint to the inside of the jug near the handle, using a strong mix of Winsor green. This is important because the stalks of the jonquils must appear to go into the jug, not sit on top of it. If the paint runs, simply blend it into the jug with a wet No.12 brush.

Mix primary yellow with a touch of cadmium red and apply a few blobs to the flower area for tonal contrast.

8 Assess the tones of the jug once more. Then turn your attention to the foreground. Use the No.12 brush to darken the shadow behind the jug with yellow ochre and a touch of cobalt blue pale.

Your aim is to achieve a sense of reflective colour from the jug, both in the background and foreground tones. As the layers of paint build up, the jug and flowers begin to sit convincingly in their space on the table. Use white to redefine the front lip of the jug with the No.5 brush.

9 Continue adding white paint to the lip of the jug. Lighten the side of the jug with your No.12 brush and a loose blob of white, and blend again.

Then blend the colours beneath the lip and around the jug handle with your No.12 brush dipped in a little water.

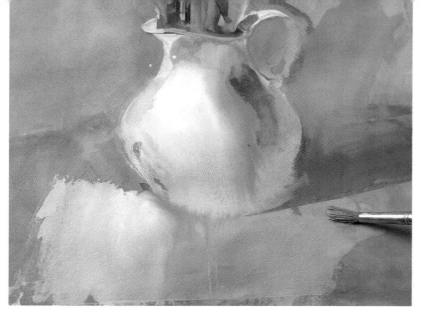

▲ **10** Add a dark reflection near the handle with cobalt blue pale mixed with warm grey No.5. Then soften the edges with the No.12 brush, and continue to blend the colours on the jug. Don't overwork this area – you'll end up with a very flat grey. Blend selectively around its sides, leaving white in the middle. Our artist then blended the colours which ran down the paper. Lighten the foreground beneath the jug using white, yellow ochre and warm grey No.5.

▲ **11** With the No.5 brush lighten some of the flower petals with primary yellow mixed with white. Flick these on using quick brushstrokes, keeping the painting's surface lively and interesting. Mix a little scarlet lake and golden yellow, and paint in the trumpet-shaped centres of the jonquils.

◀ **12** To suggest roundness and depth, tidy up the stems using the same brush and three colours: Winsor green and cobalt blue pale; permanent light green; and Winsor green and lemon yellow. Then, using your thumb, merge the colours around the jug handle where the reflected light on the ceramic meets the colour of the background.

▲ **13** Mix cadmium red with spectrum yellow to intensify the colour in the flower centres. Add more detail to the stems and the leaf tips appearing through the blossom with the three green mixes from step 12. Use your No.5 brush.

Wash your brush, then add thick blobs of primary yellow mixed loosely with white to break up the uniformity of the flower mass and suggest individual flowers showing through.

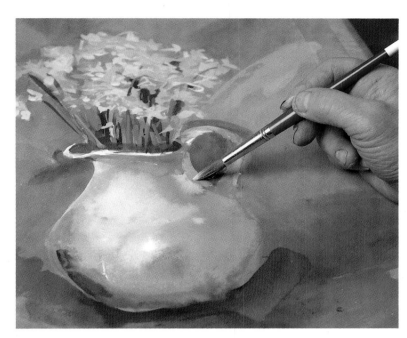

14 Now that you've nearly finished, move your easel to the flat position or lay the painting on a table to prevent the paint from running. Use your No.12 brush to build up the layers of grey on the jug. Apply warm grey No.5 mixed with a little white. Add cobalt blue pale and Winsor green to this mix for the shadows underneath the jug.

Tip

A plateful of good advice
Why spend a lot of money on shop-bought palettes for watercolours when an ordinary white ceramic plate works equally well, if not better? It's cheap, offers a large working area and is easy to clean under warm running water.

15 For the jug's pattern, our artist used small strips of folded paper as a tool, instead of a brush. Practise applying the paint on a piece of scrap paper before working directly on to the painting.

Dip the folded corners into cobalt blue, and print the paint on. Use the paper straight and curved to help you capture the pattern, but don't copy it slavishly.

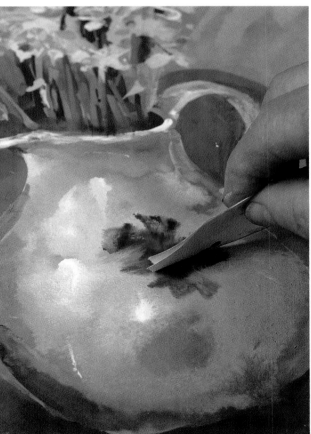

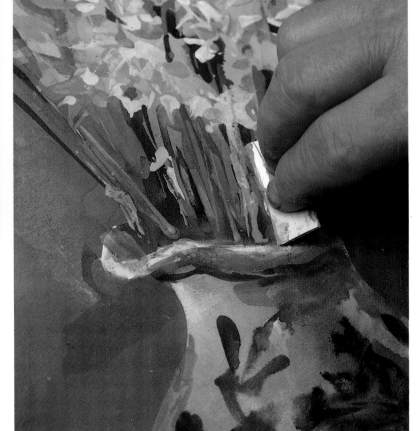

16 Mix some permanent light green and primary yellow, and apply this with the paper strips to make extra fine lines along the stems. Again, resist the temptation to make too many stems, or the painting will look overworked.

Some blobs of paint may accidentally appear. Don't worry – these give your painting spontaneity.

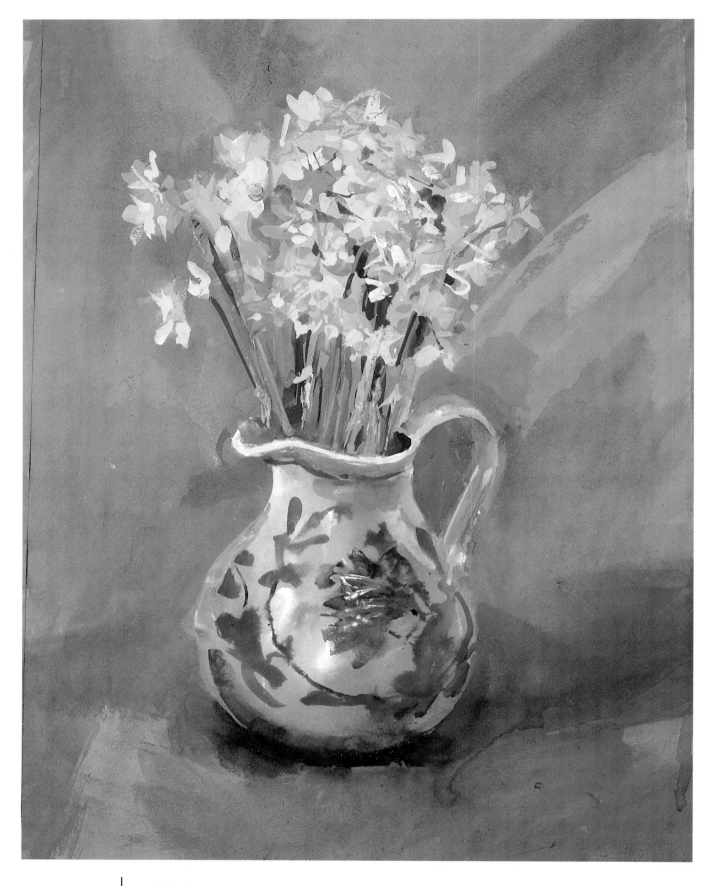

▲ **17** Add pure white highlights to the jug and sharpen the blue pattern, using your No.4 brush. Mix cobalt blue pale and a little cadmium red for the darkest area underneath the jug.

The finished painting has been left fairly simple.

Our artist overpainted many different yellows to give an overall impression of a vase of flowers without labouring unnecessarily over each one. And parts of the tinted paper show through in areas to add warmth and pull together the whole image.

Bringing out the whites

With gouache you don't have to work on white paper if you want your painting to include white – just add it later.

Since you can add the whites at any stage with gouache, artists often start on a coloured ground. This has the same advantages as when painting with oils, providing a good mid tone against which to judge the other colours and helping to give the painting an overall harmony. However, gouache remains soluble in water, even when it has dried on your paper, so start with a coloured paper or tint it with acrylic, as our artist does here, to avoid disturbing the colour later.

To begin with, work with thin washes, gradually thickening the paint as the picture develops. This helps overcome the tendency gouache has to look flat and lack sparkle. By working on a ground full of texture and interest that shows through several layers of paint, you keep the picture surface alive.

For this demonstration our artist worked dark to light, using whites to transform the picture into one rich in contrast, depth and atmosphere, evoking strong afternoon sunshine.

◀ **The set-up** Our artist worked from a photograph of cottages in the countryside. He prepared his support – thick white cardboard – by brushing a dilute mix of cobalt blue and Payne's gray acrylic paint over it with a 2in decorator's brush, deliberately allowing the brush marks to show for a more interesting effect. He then allowed it to dry completely.

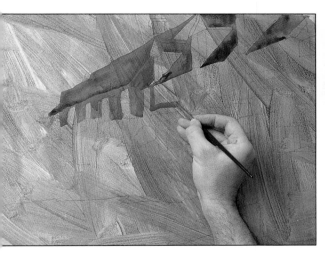

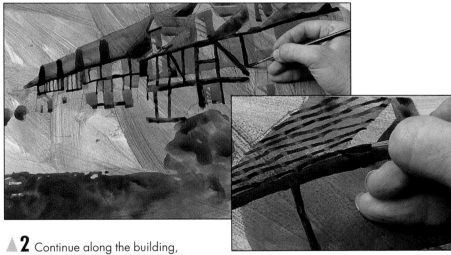

▲**1** Sketch in the composition carefully with the 3B graphite stick. If necessary, adjust or edit what you include to improve the composition; our artist left out a large tree on the left and extended the image upwards to include more sky and chimneys. Position the row of buildings, draw in the timbering and windows and roughly describe the surrounding shrubbery and trees.

Begin painting with a watery mix of ivory black and raw umber for the dark areas of thatch, using the No.12 brush. Wash in the tiled roofs with some cobalt blue added to this mix. Switch to the No.5 brush and paint the bluish shadow cast from these roofs with a fresh, watery mix of cobalt blue and a touch of ivory black and raw umber.

▲**2** Continue along the building, intensifying the wash with Prussian blue on the right. Block in the windows and then, adding more Prussian blue and black, put in the dark shadow on the road with the No.12 brush. Dilute the paint further and put in the shadows under the eaves and on top of the bushes.

Use the No. 5 brush to paint the dark areas under the roofs with a mix of ivory black and Prussian blue. Continue along the guttering under the tiles and along the timbering and windows. Don't use the paint too thick – keep the brushstrokes loose and fluid. Paint the shadow under the tiles with short, jerky strokes to break the line (inset). Leave to dry.

YOU WILL NEED

- A 15½ x 22in sheet of thick white cardboard, taped to a board
- Table easel
- One 2in decorator's brush and two round synthetic brushes: Nos.5 and 12
- Hair dryer
- Palette (our artist preferred to use a sheet of glass for this)
- Two graphite sticks: HB and 3B
- A few jars of clean water
- Fourteen gouache colours: ivory black, white, cobalt blue, Prussian blue, sky blue, raw umber, yellow ochre, spectrum yellow, cadmium red deep, scarlet lake, magenta, orange lake light, sap green, permanent green middle

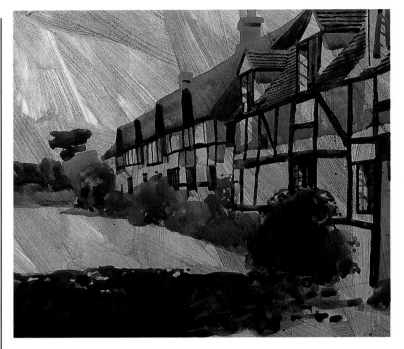

3 Intensify the shadow on the road with a mix of cobalt blue and ivory black. Use this mix to outline the windows and frames, paint the open window, the dark panes of the door and the dark shadows on the chimneys.

Still with the No.5 brush, and a yellow ochre/cadmium red deep mix, block in the chimney tops and the dark door panels. Work over the bushes and distant tree with varying shades of green mixed from sap green, permanent green middle and touches of yellow ochre and black.

4 Search for the lights and darks, keeping your brushwork lively. Try rolling your brush to break the stroke of paint as you block in the bank of bushes in the background. Spatter paint over the area to add interest and suggest the natural shape of the foliage. Push your chimney mix towards yellow by adding more yellow ochre and some white, then brush this loosely over the road.

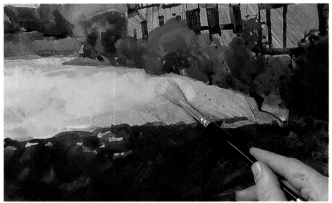

5 Make a thin mix of sky blue and white and use loose, free strokes to paint the sky, working around the tree, chimneys and hedges with the No.5 brush.

6 Now stand back. Already the picture has a sense of distance and perspective but it looks a little flat. In the next steps you will transform it by adding white.

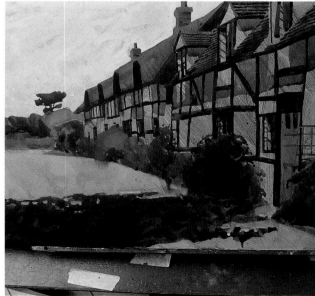

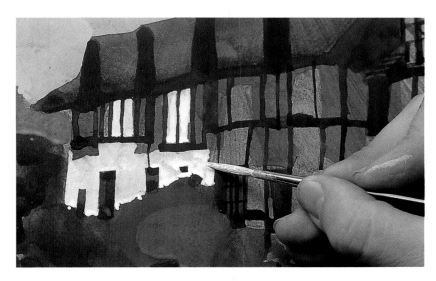

7 Begin to fill in the white walls, working around the dark timbers with the No.5 round brush. Correct shapes and profiles with the white as you work around the bushes.

8 Continue working on the walls, not forgetting the parts over the dormer windows in the cottage roof. Try to show the slight imperfections in the ageing timbers and bowing walls which give character to the building.

Start to put in the details now: add some raw umber to the white for the sunny strip at the end of the road. This leads the eye back into the distance. Add small, light touches of white in the bushes and spatter washy white on to the road to create texture.

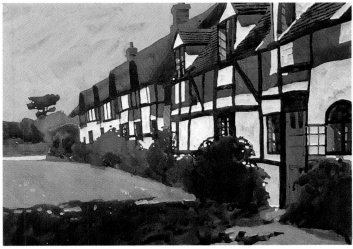

9 Touch in more highlights on the bushes with a mix of spectrum yellow, sap green and a little white. Add more white and thin the paint, then speckle in the laburnum flowers, blending areas together for a mottled effect. Spatter this mix over the bushes too – interesting watermarks will form as the puddles of paint dry. For darker detail in the bushes, use a mix of ivory black, Prussian blue and sap green throughout.

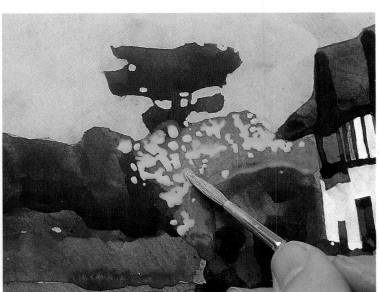

10 For the tiny pink flowers on the bushes, use the No.5 brush and dab on spots of magenta mixed with a little white.

11 Paint the roses in front of the houses with speckles of orange lake light and white, adding scarlet lake for the distant ones. You can try lightly spattering some clear water on to the bushes and over the roses – when dry, these will create a dappled effect, suggesting foliage.

12 Brighten up the walls in places with some fresh white paint. Using the white paint quite thickly renders the texture of the brickwork exceptionally well. Work neatly between the leaves and flowers. Define the bricks with your graphite stick.

13 With your HB graphite stick, draw lines along the road from background to foreground, suggesting the tracks of passing cars. Your picture is now nearly complete, but you can still add tiny touches, pushing and pulling the colours and enlivening areas that look a little flat if you wish. The beauty and strength of gouache is that it allows for constant changes.

Part 3

ADD EYE-CATCHING INTEREST TO YOUR ACRYLICS

Snow: dealing with white

When painting a snow scene it's not enough simply to dab a lot of white paint everywhere – you need to look for shadows and the myriad colours reflected by snow.

For a snow scene in watercolour, you need to plan the picture carefully so the snow is rendered by the white of the paper itself. But with acrylics things are different. In the demonstration overleaf our artist set out to paint a snow scene – but he started with a dark, smoky, purply ground. This, though painted over almost at once with quite a bit of white, gives an underlying solidity and bulk suggestive of the land beneath. The spiky, wispy bits of grass sticking out of the snow then look as though they are rooted in the earth.

Our artist works methodically: from dark to light at first, then back to dark again; this establishes layers of subtle shadow and tone which echo the initial dark tone and impart an vital balance between warm and cool colours; the final addition of bright white highlights give sparkle and coldness to the wintry scene.

Note that our artist used only five colours, in a subtle combination of warm and cool neutrals. He has included quite a lot of warm tones – ochres and mushrooms – as well as the various cool blues and greys you would expect in such a wintry scene. Snow can impart a muted, low-key tone to the countryside, especially when the sky is overcast. The small number of colours used here makes for great overall harmony and unity.

Remember that snow is not only white or grey. It's full of other colours, reflecting everything around it and forming deep shadows where there are hollows, dips and irregularities in the ground.

Using references

You can't always guarantee to come across the ideal composition for a picture – and have a sketching pad to hand at the same time. It is essential to build up your own personal library of references, from as many sources as you can, so that you can put together the kind of picture you want when you feel inspired to do so. This is just what our artist has done here. He has married

elements from three different snapshots (overleaf): of his cat stretched out lazily on the patio in summer, of wisps of dry grass at the edge of the hedgerow and sticking up through freshly fallen snow, and of a couple of hollows formed by the weight of snow bending down the grass and twigs. The combination of all three suggested the composition put together overleaf – Spitz the cat waiting by a mousehole in the snow.

▼ This extraordinarily rich yet very wintry scene has been achieved with a limited palette of colours that combine for an effective balance of warm and cool neutrals brightened by the judicious use of sparkling white.

' Snipe in Snow' by Richard Smith, acrylic on hardboard, 12 x 10in

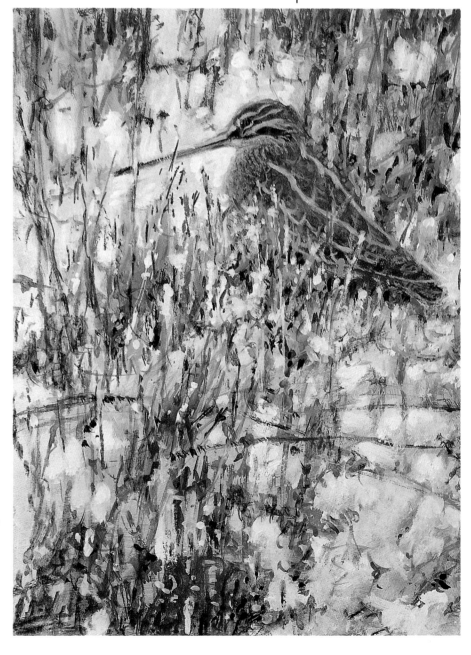

Spitz – waiting in the snow

▼▶ The set-up Here are the three snapshots used by our artist as his starting point.

Since snow doesn't often lie on the ground for long, it's particularly important to build up as many references of snow scenes as possible.

Our artist thought the cat's striking markings would be perfectly set off against the whiteness of snow.

◀1 Mix yellow oxide, burnt umber, ultramarine, red oxide and a little titanium white to make a purply, grey-green colour and, using the decorators' brush, scumble it loosely on to the hardboard to seal the surface. Leave to dry thoroughly, then rub down with sandpaper for a smooth surface free of any lumps, bumps or irregularities.

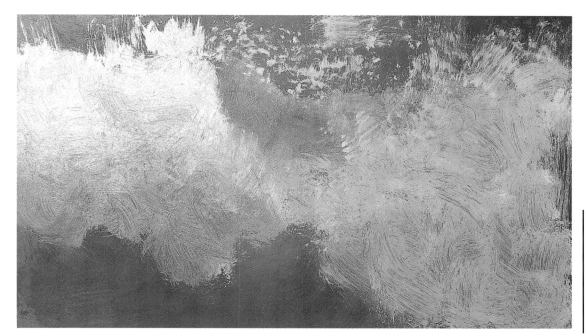

◀ **2** Dip the old shaving brush into some water, then into some white paint warmed with tiny amounts of yellow oxide, ultramarine and a touch of red oxide. Mix these lightly on the palette and lay a band of dirty white paint over the centre of the board. Don't allow the colours to mix too well – the greater the irregularity the better the picture will look.

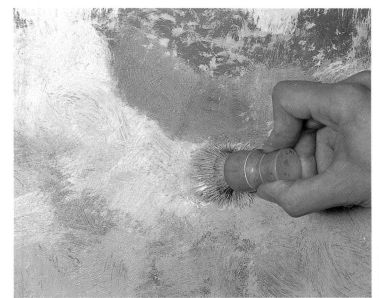

◀ **3** Lay more white over the top left of the picture, and in the centre. Each layer of white should be slightly whiter (less mixed with other colours) than the one beneath. Eventually the whole board is more or less covered with a whitish mix.

Experiment with the shaving brush to see the range of effects you can come up with – press hard, press lightly, and sweep and swirl and circle the brush around to achieve variety, vigour and texture in your marks.

▼ **4** Add a touch of burnt umber to the white mix to make a warm mushroom colour and apply it with the shaving brush in two patches, one slightly to the left of centre and one rather more to the left and slightly lower – these form the deep, darkly shadowed hollows which are going to be the main focus of the cat's attention.

5 Add some yellow oxide to the mushroom mix to warm it even more, then dab it very lightly here and there to suggest underlying vegetation.

Note that though the whole board is covered with a mixture of white and the other four colours from our artist's palette, you can still see something of the coloured ground showing through – it 'informs' and bulks out the 'snow' applied on top.

▶6 Mix burnt umber and ultramarine to a dark mushroom colour (you now have two mushroom mixes – one warm and one dark – on your palette). Start painting in the outstretched, furry figure of the cat with the shaving brush. Dab in the head and one ear in the dark mix, then put in the neck and ruff in warm mushroom. The body and bushy tail go in dark and warm together (the white underneath comes through these light dabbing strokes). Just indicate the back legs with a few dark dabs.

Put in dark accents with heavier applications of the darkest mix, dabbing here and there on the head and body. Leave to dry thoroughly.

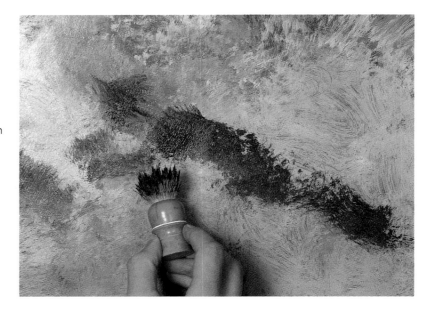

◀7 Change to the No.4 brush and make up a bluer mix of ultramarine and burnt umber to a very rich, almost black colour.

Using the edge of the brush and thick paint, touch some of this on to the cat's head, front paws, shoulder, tail, back legs and flank. Blend the wet paint slightly so the edges become 'furry'. Also dab in tiny dark accents for some of the darkest shadows above the cat and to the left where the two deep hollows are. Leave to dry.

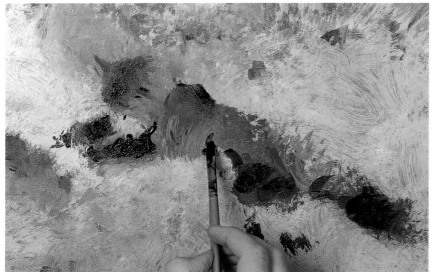

▶8 Outline the underside of the cat with a thin, dotted line of pure ultramarine, establishing a slight shadow area. Wash the brush thoroughly. Then, using almost pure white paint, block in the white tummy of the cat above the ultramarine line, and also the white socks on its front paws and the spot of white on its chest. Modify the white with a touch of ultramarine and paint in the light areas on the cat's back legs and under the flank. Wash the brush thoroughly once again.

9 Now you want to make the cat appear as though it is nestling into the snow – the foreground should look as though it is touching the cat.

Mix lots of white into your warm mushroom mix on the palette (this is a dirtier white than that used for the white of the cat's fur) and paint in under the cat's tummy and in a half moon shape between the back legs and tail. Dab the same colour around in the foreground.

All the time use your paint and brushstrokes to make small adjustments to the outline of the cat, redrawing and developing its shape so it becomes more accurate and life-like.

10 Redefine the white parts of the cat, especially the front paws and belly, to bring them forward. Put in more detail on its head with the No.2 rigger – tiny flicks of white on the ears, the cheeks and the side (don't forget the whiskers).

Fill out the head, body, flanks and between the paws with drybrush dabs of both the warm and dark mushroom mixes and the nearly-black colour, modifying the cat's shape as you work.

Go over the darkest parts of the fur with a soft, bluish mix – head, shoulders, side and tail – to build up the texture and colour of the cat.

Tip

Keep things damp
Our artist used Liquitex acrylic colours in plastic tubs. To save on tedious opening and closing of the tubs, from time to time he sprayed a little water into them from his aerosol container – this is especially useful if you have to stop for lunch or are interrupted. The paint stays workable and you can return to your painting without delay.

11 Now for the snow. Returning to the No.4 brush, make up an off-white mix with just a touch of blue/brown and work around the cat in the foreground. Touch in more white on its back legs. Spread more of the snow mix here and there – at the top of the picture, on the left, and between the weeds and grasses. At this stage you are using the paint quite dry, highlighting the lighter parts to give more of an impression of snow.

◀ **12** Still with the No.4 brush and pure white paint, put in more dabs for snow – again around the cat's tummy and paws and in the shadow areas. Build up the picture in small drybrush dabs all over, 'dusting' the paint on with light jabs and dabs of the flat brush, turning and twisting it in every direction to give variety, texture and interest. Use different densities of paint – some thin glazes, some soft scumbles.

Also start putting 'harder' white in places, using thicker paint, particularly around the main shadows and in the top third of the picture.

▶ **13** Mix yellow oxide, a tiny touch of red oxide and burnt umber and, with the No.2 rigger brush, start flicking in grasses in the top third of the picture. Flick paint on for the stalks on the right side with an upward movement and small, speedy strokes that suggest the brittleness of the dried grass.

Use the same mix – a 'French mustard' sort of colour – to dab in areas all along the top of the picture. The mix shouldn't be too thorough – sometimes it can be more mustardy, sometimes darker.

◀ **14** Darken the mustardy mix with a touch of ultramarine and burnt umber and put in some more darks on the top third of the picture. Add some dark shadows on top of the central shadowy hole – the cat is waiting for something to appear from there! Flick in more grasses in various places with the darker mix.

Keep on touching up all round the top third with the dark mix to give texture and tone and some idea of the grasses standing out from the recessive shadows at the top. All the time use the previous mixes on your palette to add to the current mix to give variety and subtle tints, hints of one colour picking up from another. Keep an eye on the balance of warm and cool neutrals as you go – the warm mustard and mushroom hues are as important as the cool blues and greys.

▶ **15a** Mix red oxide and ultramarine to make a rich berry purple for darks around the grasses and shadows in the top third of the picture. Put some of this in the shadow of the central shady areas.

◀ **15b** With the No.2 rigger and the same black-purple mix, flick in some grasses at the bottom right of the picture. Use pure yellow oxide to flick in and scribble more grasses on top, under the shadowy parts.

▶ **16** Return to your No.4 brush, dip it in water and matt medium and make a very thin opaque scumble of yellow oxide. Apply this to the left side of the central shadow to warm it up a bit. Scrub it over the whole cat and much of the snow to pull the whole picture together. Drag the brush quickly over the area – the paint dries quite fast.

Return to the purple mix and thin it with the matt medium and a little white (the purple is complementary to the yellow). Apply it round some of the yellow patchy areas.

Mix a thin glaze of burnt umber and use it to soften the fur on the cat – stay with the No.4 flat brush for this.

17 Use more pure white and the No.4 flat brush to touch up the white fur on the cat's tummy, paws and legs. Also highlight the snow patches in the top third of the picture and down the right.

Flick in white highlights in the grass at the bottom left and on the grasses at top left. Dot white here and there to highlight the clumps of grass on the right.

Change to the No.2 rigger brush and add quite wet pure white flicks to the dark areas at bottom left for sparkle and to add 'cold' effects – do the same sparingly all over the grassy areas.

18 In the finished painting the very limited palette of only five colours unifies the whole picture, holding it all together. The use of three separate references has helped the artist compose a charming picture which suggests well the cold wintry day and the patience of the cat waiting for its prey.

Note that the artist renders the snow with both warm and cool colours – yellows and browns balanced against blues and greys. He gives the snow depth by layering and scumbling transparent and semi-transparent colours over each other, thereby capturing its intricate complexities.

Using a viewfinder: still life

A viewfinder is the simplest of devices – just a piece of cardboard with a rectangular hole in it. But it can have a startling effect on your painting, opening your eyes to previously unseen compositions.

Our artist had long been contemplating painting the potted plants in the corner of her living room – the question was the choice of composition. A beginner might have tried to paint all the plants as they were, ending with a confused image. Another option would have been to re-position the plants so they formed a pleasing arrangement. However, doing this means turning to old tried-and-tested formulas.

To make life simpler, our artist turned to a viewfinder. This is a piece of cardboard with a rectangular hole in the middle. It has the effect of isolating and framing your subject matter, helping you 'read' it in purely compositional terms.

She spent some time simply looking through the viewfinder, studying the various compositions that could be made from the plants as they stood. She eventually moved in quite close, omitting the geranium altogether. The frieze of pale primula flowers in the top third particularly caught her eye – this plays off against the white tablecloth in the bottom third.

Also, moving in close emphasized the three-dimensional quality of the bowl, so that in the final painting it almost seems to advance from the picture plane.

▲ **The set-up** At first glance, the array of potted plants on our artist's sideboard did not look a very promising composition. But by using a viewfinder, she isolated the most attractive features – especially the bowl and the primula flowers – in a tight, dynamic composition. To finish, she added the cup which provided an echo of the shape of the bowl, and some artfully placed cherries.

◀ **1** Begin very loosely with the No.9 brush. Use a mix of chrome oxide green and chrome oxide yellow to put in the foliage, and mixes of permanent rose, cadmium yellow light, cadmium red light and olive brown for the flowerpots. For the shadow tones in and around the bowl, try mixes of ultramarine and olive brown. Then block in the outside of the bowl with titanium white and a touch of cadmium yellow light.

2 Intensify the colour of the flowerpots by adding more cadmium red light and cadmium yellow light to your mix – the result is a beautiful terracotta. At this stage these tones are experimental, so use very watery washes.

3 Concentrate now on the main leaf using the No.3 brush and a mix of cobalt blue and cadmium yellow light. Add a little cadmium red light when working on the right side of the leaf to pick up the colour reflected from the flowerpots.

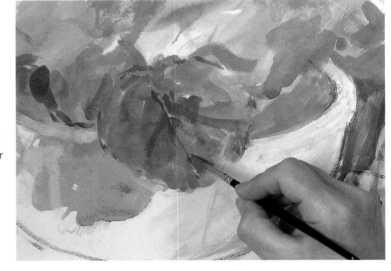

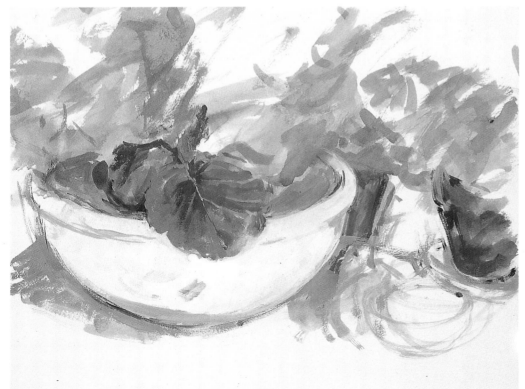

4 Since you've been working on the leaf in detail, stand back now and assess it in the context of the whole painting. Working with daylight, as here, often encourages you to bring each part of the painting to near completion before the quality or the direction of the illumination changes. This is perfectly understandable, but always bear in mind the part's relationship to all the other elements in the picture.

Develop the shadows around the bowl with your ultramarine and olive brown mix, tinged with white.

5 Use the No.3 brush to begin on the primula flowers above the leaf. Apply titanium white first then overlay a mix of permanent magenta and permanent rose. Begin using the mix very diluted. (Remember, the pink colour will appear very powerful when set against white. Also acrylics tend to darken when they have dried.)

6 Continue building up the white flowers, working from the middle of the picture outwards. Apply the titanium white quite thickly so the green doesn't show through. Put in the centre of the flowers with cadmium yellow light knocked back with a little ultramarine.

7 Use a mix of permanent rose and a little chrome oxide green for the flowerpot on the extreme left. This gives another exciting, slightly bluer red – appropriate for the flowerpot because it is in shadow.

Now the picture is taking shape, but it needs tightening up with more detailed work.

8 Still with the No.3 brush, use chrome oxide green for the decoration of the bowl. When this is dry, you can sharpen up this pattern by re-working titanium white around the edges. Remember to paint this decoration slightly larger towards the centre of the bowl so that you create a sense of recession.

9 Loosely paint the floral design inside the bowl using ultramarine and chrome oxide green. Our artist also added a line of white inside the bowl to indicate a crack. This helps emphasize the bowl's rounded form.

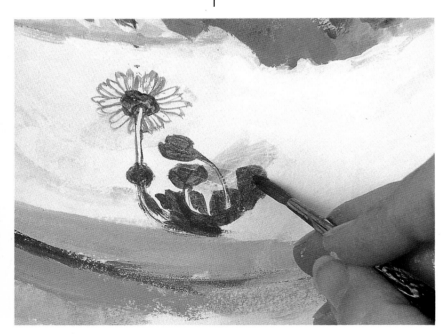

10 Begin on the foliage of the daisy motif in a mix of chrome oxide yellow and ultramarine. Carefully outline the petals in a weak olive brown and indicate their colour with a little of your permanent magenta/permanent rose mix.

11 Now you are moving on to the really detailed work. Use the point of the No.3 brush to add some pinks to the tips of the other daisy petals with mixes of permanent rose, permanent magenta and a little ultramarine. These pinks pick up the colour of the primula flowers.

Use chrome oxide yellow for the stems. Add a little cadmium red light to this yellow to put in the slightly orange centres of the flowers. Indicate the butterflies more loosely with appropriate colours from your palette.

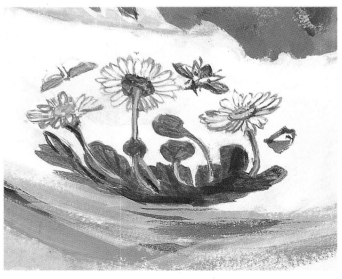

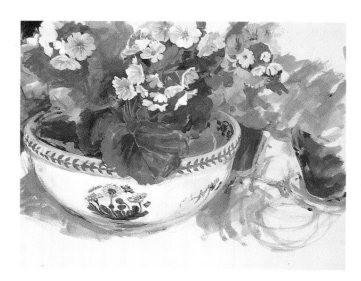

◄12 Make sure you constantly take breaks from the detailed work. The pattern of the bowl requires close attention to your subject matter, but also keep an eye on the other objects you've painted. When you become engrossed in intricate details you can lose a sense of scale.

►13 Now add some darker permanent magenta on some of the more colourful flowers. Even when blocking in deep colour, make sure your brushwork follows the contours of the petals.

◄14 Continue working up the flowers and the foliage. Use some olive brown in your foliage mix on the right. Paint these leaves loosely to contrast with the sharply defined flowers.

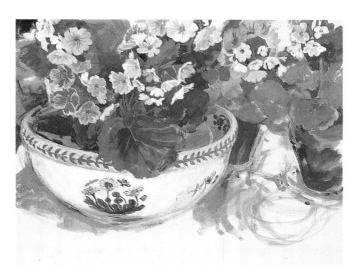

►15 Now concentrate on the foreground details. Paint the cherries in mixes of permanent rose, cadmium red light and a little ultramarine. Use bluer mixes for the shadowed sides of the cherries and redder mixes for the lighter sides. Add tiny specks of titanium white for the highlights. Indicate the stems quickly and loosely with one of your leaf mixes.

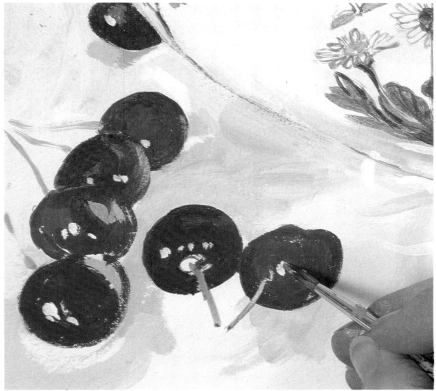

▶16 Begin on the bottom right area by putting in the shadow tones around the cup with your mix of ultramarine and olive brown. Then very tentatively put in the ellipse of the cup with a mix of cadmium red light and ultramarine. Develop the saucer of the pot behind the cup with your blue-grey and brown mixes.

▼17 Use ultramarine/olive brown for the shadow in the cup. Block in the rest of the cup with titanium white. Apply mixes of chrome oxide green and chrome oxide yellow for the brown pattern edging the rim and handle. Paint the red triangle with a mix of cadmium red light and permanent rose.

▼18 In the final painting, you can see how the close cropping has helped give a tight, lively rendition of the subject matter. The artist has not artificially isolated a single plant, but attempted to show the plants as one might glimpse them on a sideboard in real life.

The process of painting was very traditional. Our artist began loosely with watery mixes, and then moved on to a smaller brush and thicker mixes to put in the details. Note also how all the detail is restricted to foreground objects, helping to give a good sense of depth.

Creating texture: rainbow trout

You don't have to limit yourself to just one technique when painting with acrylic. Why not combine knife-painting with brushwork or glazing to create exciting textures, rich colours and subtle details?

Combining techniques allows you the scope to achieve the precise result you want. With knife-painting you can cover the support quickly and create realistic textures, such as the gravel riverbed and weeds that you can see in this painting. Our artist used brushes for details such as the trout's spots and stripe and the reflections of sunlight on the gravel. You can also use brushes for the glazes, which unify the whole scene. (Alternatively, a piece of sponge works just as well.)

Work freely and quickly, and resist the temptation to overwork an area or, for that matter, the whole composition. Exact detail is fairly blurred – remember that you're looking at the main subject (the trout) through moving water which is tinged brown. The painting lends itself to interpretation: no two people will see – and paint – exactly the same thing.

Even if you make a mistake or aren't happy with any part, you can simply paint over it – wonderfully versatile, acrylic dries quickly, allowing you to start again without wasting too much time.

For this painting, the artist bought a rainbow trout for reference. An angler himself, he had many times seen trout in weedy, rainfed rivers, and had a built-in memory to draw on. It's a good idea to make a sketch or two to use as a guide while you're working.

▼ **1** Using a white Conté crayon, roughly estalish where the gravel, weeds and trout are to go on your board.

Squeeze some blobs of yellow ochre, burnt umber and titanium white on to your disposable palette. Now start painting the riverbed area, using the whole blade of your 70mm (27½in) knife to spread irregular areas of paint. Opaque colours such as these are excellent for blurred underwater scenes.

Make full use of the tip of your painting knife, which is excellent for adding circular blobs of colour. You'll find colours mix on the surface, with parts of the black board still showing through.

YOU WILL NEED

- ☐ A 20 x 30in piece of hardboard primed with matt black emulsion/latex paint
- ☐ White Conté crayon
- ☐ One painting knife 55mm (21½in) long and one 70mm (27½in) pear-shape
- ☐ Four synthetic brushes – Nos.4, 5 and 9 round; No. 9 long flat
- ☐ One cotton rag
- ☐ Two jars of water
- ☐ Disposable paper palette
- ☐ Acrylic matt medium (for glazing)
- ☐ Ten colours – yellow ochre, cerulean blue, azo yellow medium, burnt umber, burnt sienna, titanium white, deep magenta, green-gold, alizarin crimson, ultramarine

2 Squeeze azo yellow, cerulean blue and white on to the large knife, and drag the tip across the board to make long, sweeping marks for the fronds of aquatic weeds.

Mix ultramarine and burnt umber to create a rich alternative to black for the shadows among the fronds of weed and under the large clump (inset). Because the first layer is still wet when the weeds are formed, the colours blend slightly, creating different tones.

3 It may not look like much at the moment, but the composition is now beginning to take shape. Remember, not many paintings develop immediately – you have to persevere, adding stages patiently so that the work gradually comes to life.

Here our artist mapped in the gravel, weeds and shadows among the fronds.

4 With the gravelly bottom and weeds painted in, our artist concentrated on the trout. Mix yellow ochre, ultramarine, cerulean blue and burnt umber; then add plenty of white to make a light grey-green.

Use the small painting knife to block in the narrow, tapered shape of the trout, and add more titanium white on top of the trout's back.

Keep any leftover grey-green mix – you'll use it later on.

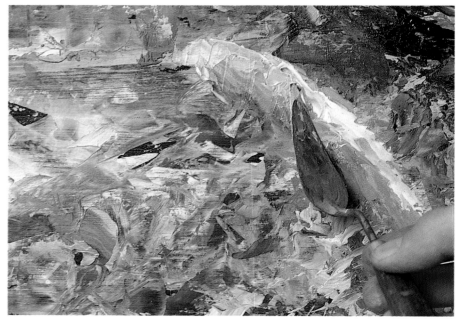

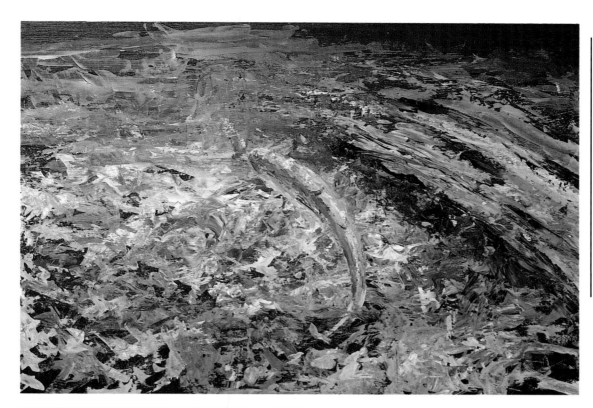

◀ **5** Continue shaping the tapered body of the trout, making angular dabs of paint to define its form. Add a little more burnt umber to the mix and darken the flank slightly.

◀ **6** Still using the small knife, paint the trout's stripe with alizarin crimson mixed with a touch of burnt umber. Add cerulean blue and azo yellow to the grey-green body colour mixed in step 4 to create a darker, richer green-grey and paint the back of the fish again. Keep any leftover paint mix.

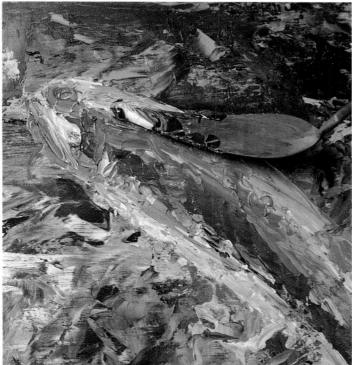

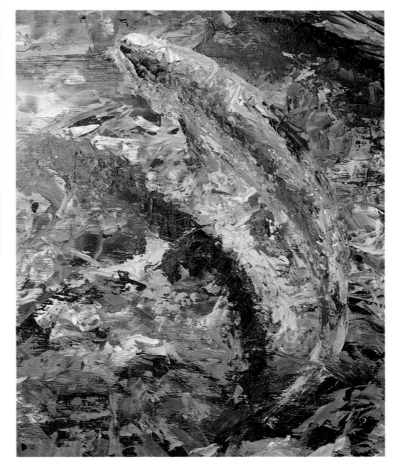

▶ **7** Don't forget to add the trout's fins (two on the top and one fin near the head), the tail and the eye – use a mixture of burnt umber and ultramarine.

For a three-dimensional effect, add the fish's shadow on the riverbed with the same mixture. Blend the edges of the shadow and the background with the No.4 brush.

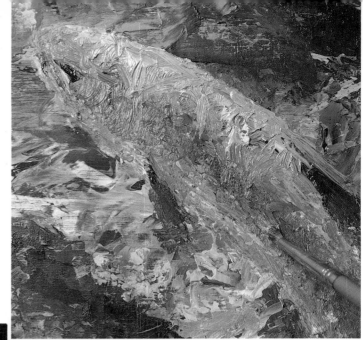

▷ **8** Add a third layer of green-grey for the trout's back (the same mix as the body in step 6). Carefully paint over the stripe again with alizarin crimson lightened with white and diluted slightly with water. Use the No.4 brush for this.

◁ **9** Step back from the painting and examine the colour and form of the composition. First look at the picture as a whole then at individual features such as the fish, its shadow, the gravel bottom and the weeds. Keep adding details where you think they are necessary.

▷ **10** Use a mixture of ultramarine and burnt umber and your No.5 brush to paint in the distinctive dark spots on the back of the fish. Remember to include the head. Outline the eye of the fish with the same dark mixture to help it to stand out.

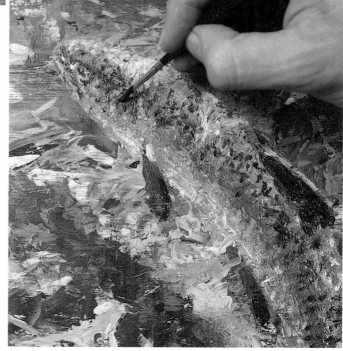

11 When you look into water, bear in mind that some areas may appear sharp but most are blurred and fleeting. You don't see exact detail at all depths (main picture). Use the No.4 brush, loaded with titanium white, to put in reflections on the gravel where the sunlight is reflected from the fish's belly on to the riverbed (inset).

 12 Make a pale mix with white, yellow ochre and a touch of ultramarine. Dab a few dotted marks on to the fish with the No.9 round brush to suggest sunlight catching the trout's back and the top of its head.

Drybrush the same mixture on to the fins to give them form and make them look more realistic.

Tip

Glazing
A glaze provides a luminous quality to the work and also unifies the whole composition. Our artist uses as many as 40 glazes in some works, gradually building up rich colours which can't be achieved by laying on a mixed colour as a solid.

13 Mix deep magenta with some matt glazing medium, and glaze over the stripe of the trout with the No.9 flat brush.

Make a lime-green mix from ultramarine and yellow ochre and use to suggest some of the scales along the fish's back and flank. Add burnt umber to this mix and paint a few more scales; then dab a few strokes in the gravel around the fish.

To re-define the curve of the fish, apply a mix of ultramarine, white and touch of yellow ochre. Leave to dry.

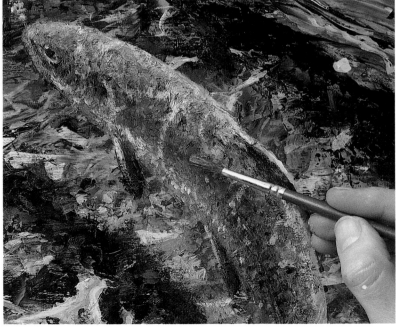

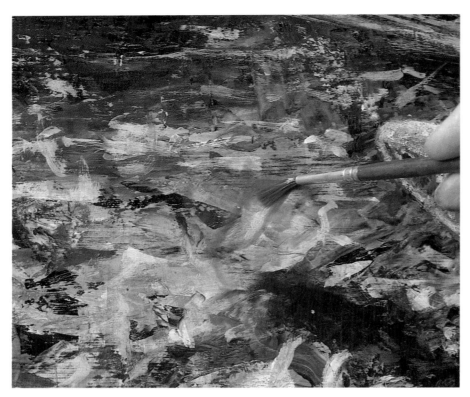

◀ 14 Mix two or three teaspoons of acrylic matt medium with the same amount of water in a jar. Pour a little of this on to your palette and mix in a small amount of burnt sienna. Scrub this glaze over the entire canvas (including the trout) with your No.9 flat brush, working in different directions to apply the paint unevenly. The colour builds up in some areas but not in others, giving a three-dimensional appearance.

Leave to dry. Then clean your brush and lay a thin glaze over the weeds with a small amount of green-gold mixed with two teaspoons of matt glazing medium.

▼ 15 Mix titanium white with a little ultramarine and add an equal amount of glazing medium to make a very light steely blue colour. Using the No.9 flat brush again, make translucent horizontal strokes to suggest the water's rippled surface. To finish, add a few feathery flicks of this colour to the fish and to the shadows, water, weeds and pebbles, using the glaze more generously in the foreground.

It's this contrast between the cool light blue against the warm tone of the burnt sienna glaze that gives the effect of sparkling, moving water.

Using texture gels

Texture gels are fun – an exciting medium to use with acrylic paints – and you can use them to build up richly textured areas quickly and easily.

Texture gels are clear gels which allow you to create impasto or textured effects easily with acrylic paints. They can be mixed with paint and then applied with a palette knife or used on their own and then painted over when dry. Some are mixed with different inert fillers such as fibres or sand to create different textures – from smooth plaster to rough sand. Look out for Liquitex's texture gels in art shops – Natural Sand, Ceramic Stucco, Blended Fibres and Resin Sand.

It's best to use a texture gel on a board or a piece of rigid card so it doesn't crack and fall off (as it would on a flexible support). To build up a considerable thickness with minimal risk of cracking, apply the gel one layer at a time, and allow each to dry between applications. Use a hair dryer to speed up the drying time, or leave the board in a warm place overnight.

It's important to link the texture with the objects in your composition. For example, make spiky marks to represent grass or sweeping, circular swirls for clouds. Resist the temptation to get carried away with too many different textures in one painting – they can distract you from important matters such as form, colour, tone and sense of perspective. You'll find that using one technique to the exclusion of others can make your work look artificial.

Our artist created three layers of different textures in this demonstration, using them to define the horizontal zones in his painting and to focus attention on the zebras.

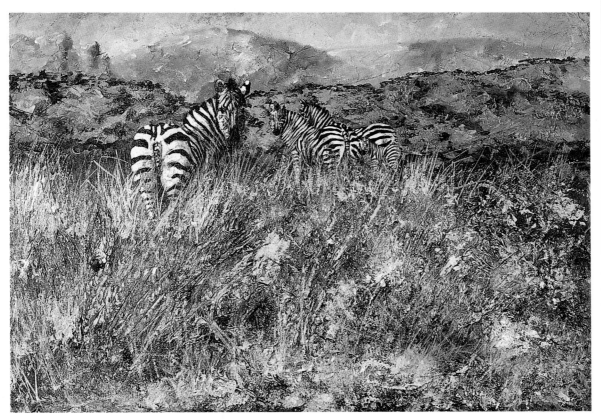

Mixing texture gel and acrylic paint

1. Use the palette knife to scoop out a generous portion of texture gel (in this case Liquitex's Natural Sand) on to your board or palette.

2. Squeeze out a large blob of paint on top of the texture gel and mix together with the palette knife.

3. Mix the two thoroughly to create an even colour, and apply immediately to the appropriate areas of the support you are using.

◀ **The three main areas of texture in this painting – foreground, hills and sky – are varied to add to the sense of space. The texture is most vigorous in the foreground, becoming more controlled on the hills and softest in the distant sky. Notice the contrast with the smoothness of the zebras.**

Zebras on the African plain

The set-up Our artist specializes in wildlife painting and has considerable experience painting African landscapes. He used his own photos of zebras as a reference. The landscape colours and details come from his memory of many trips to Africa.

Follow his composition if you like, or find your own references in the fields and countryside nearer home. The aim here is to have fun and see what you can achieve with the various texture gels available.

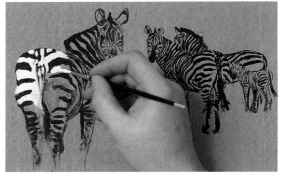

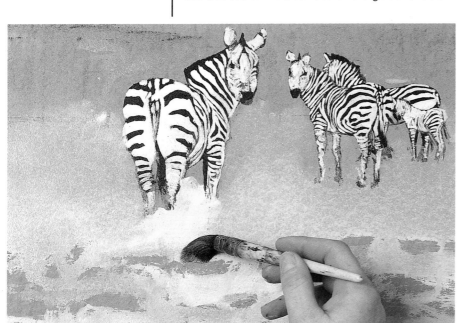

▲ **1** Take time to work out your composition. Assess where sky, mountains, zebras and grassy foreground are to go. Then sketch the zebras on the board with the pencil. With the No.4 round brush, paint in the stripes with a warm black (ivory black and burnt umber).

Apply a thin wash of titanium white to the other stripes with the same brush. Build up the intensity of the white by adding a layer of titanium white mixed with a little cadmium yellow light.

◄ **2** Fill in the mountains with dilute cobalt blue and white (use the ½in decorators' brush). Make up a wash of Turner's yellow and titanium white, and paint around the zebra's feet, down to the foreground.

Increase the thickness of your paint as you move down. Our artist rolled the brush in his hand and turned the paint on to the board, applying it thickly and loosely in the foreground.

▶ **3** Now for the texture gels. Loosely mix Liquitex's Blended Fibres with Turner's yellow and titanium white (mix loosely – the streaks of pure colour add to the textured effect). Apply the mix to the foreground and over the zebras' legs with a palette knife.

You can make several types of marks with the knife. Use the flat side to sweep broad, smooth areas or make short, wave-like marks. Draw with the edge of the blade, introducing sharp, vigorous movements.

The thick gel tempts you to move the paste around. Let yourself go! Use fingers to make bold channels in the foreground, creating a variety of textures (far right, top).

Soften the gully-like marks with the end of the paint brush

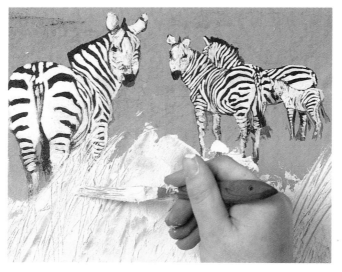

(far right, bottom). Notice the strong directional movement of the grassy foreground area. When you apply the paint, it will appear to shimmer with life.

4 Boldly block in the sky and mountains with the smoother Ceramic Stucco gel, using the flat underside of the palette knife.

For the low hills use Liquitex's Natural Sand. Apply a thin layer to the board; don't worry about covering the area totally. Lay the underside of the palette knife flat on the board then lift it up and down to create little choppy waves, suggesting the low hills. Notice that the more vigorous marks are confined to the foreground.

Leave the painting to dry. At this stage the gel is opaque, but it becomes transparent when dry. If you leave the board in a warm place overnight, the texture gels dry completely in one night.

5 Once the texture gels are completely dry, apply a mix of cerulean blue and white to the top part of the sky, using the 1in flat brush. Vary the mixture to achieve a mottled effect.

6 Add a little diazin purple and Hooker's green to darken the sky mix, and apply this vigorously to the mountains with the No.4 flat hog brush. (Use hog brushes on the sharp, hard textures because they don't wear out as quickly as soft brushes.)

Dragging pure white over some of the textured peaks creates interesting highlights. Make sure you keep the highlights on the same sides of the mountains to indicate the correct direction of the light source.

YOU WILL NEED

- ☐ A 24 x 17in piece of primed medium-density fibreboard
- ☐ One 2B pencil
- ☐ Seven brushes: 1in flat, ½in filbert, No.4 rigger, Nos.00 and 4 round, No.4 short flat hog and a ½in decorators' brush
- ☐ A palette knife
- ☐ Daler-Rowney Stay-wet palette
- ☐ A clean cloth
- ☐ Jars of clean water
- ☐ Acrylic thinner
- ☐ Liquitex texture gels: Ceramic Stucco, Natural Sand and Blended Fibres
- ☐ Twelve acrylic colours: Naples yellow, Hooker's green, burnt sienna, cadmium yellow light, titanium white, burnt umber, ivory black, cobalt blue, Turner's yellow, cerulean blue, diazin purple, Acra gold

7 With the same brush, apply Hooker's green with various amounts of diazin purple to the low hills. One mix would make the hills look flat, but a variety of tones creates a sense of distance.

Add a loose burnt sienna mix on some of the hills to vary the tones further, and again go over the area with more green tones until you're happy with the results.

8 Dab on short strokes of burnt sienna mixed with a touch of Hooker's green to indicate the scrubby trees on the hills. Use the ½in filbert brush for this. Follow the lines of the hills and add a few random groupings to create the impression of clumps. Then use the mix to lay a dark band at the base of the hills (by the distant group of zebras' legs).

9 Stand back to assess the depth and tones. Notice the accurate sense of perspective achieved – you can see the heavy textures in the foreground details; they fade as your eye moves farther and farther into the distance. The indistinct purplish mountains with contrasting light and dark areas lie convincingly in the background, well past the low foothills.

Redefine the single zebra on the left, using your small No.00 brush. Paint over the white stripes first and then the black with the mixes you used earlier.

(You may want to use your thinner at this point to help the paint cover the support easily.)

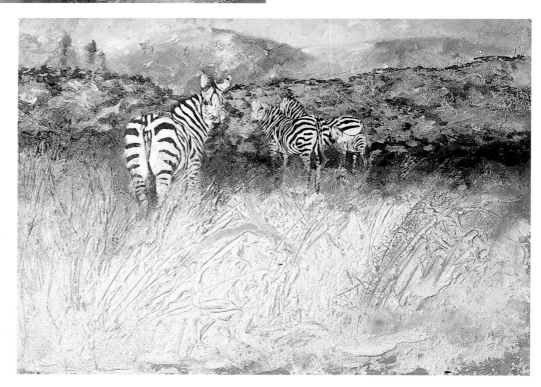

▶ **10** Now turn your attention to the far group of zebras. Sharpen their stripes with the same brush and the mixes used earlier. Ensure the ear and eye details are sharp and clear on all of them.

▲ **11** If you think the zebras appear too clean and well groomed, apply Acra gold with a small brush along the edges of the main stripes. Smudge the colour with your finger to produce a wonderful blurred effect. Then add a dilute layer of titanium white to brighten the zebras slightly, allowing the warm gold to show through.

▶ **12** Squeeze out a generous amount of Acra gold on to your palette. Scrunch up the clean cloth, and dab on the paint, applying it at random to the foreground area. Scrub the paint roughly all over the texture, but don't cover it uniformly.

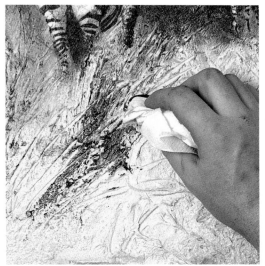

◀ **13** Repeat this several times with other colours (unmixed) – Naples yellow, burnt sienna, white and a little cobalt blue. Layer them, light then dark, slowly building up deep tonal contrasts on top of the texture.

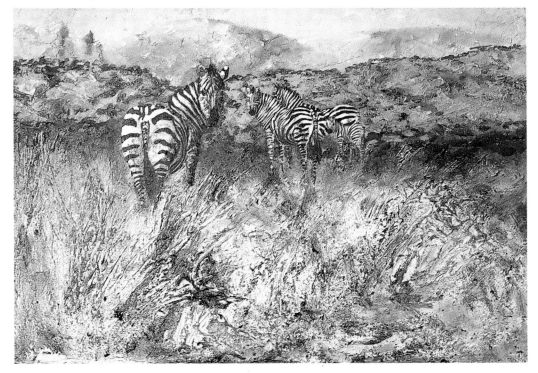

▶ **14** Continue building up colour until you're happy with it, then add the final details with the No.4 rigger. Mix Naples yellow and white, and flick the brush loosely, making fine strokes for wisps of grass.

Again, use thinner if you need to make the paint move around easier.

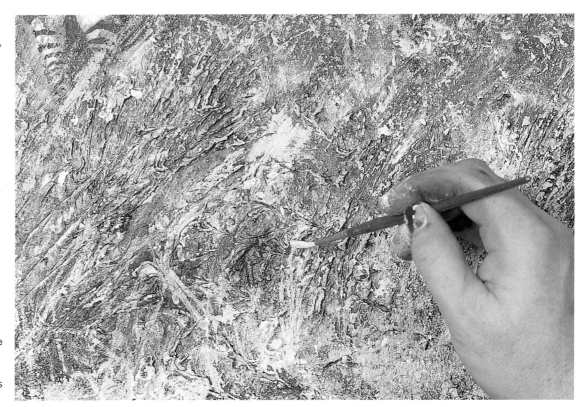

▼ **15** Check that the zebras are clear; sharpen their faces and stripes more with a dilute layer of titanium white if you wish. Use the No.00 brush.

The final image has three different horizontal bands of texture which add interest to the African landscape. All three help to contrast and define the pattern of the zebras, and focus your attention on them.

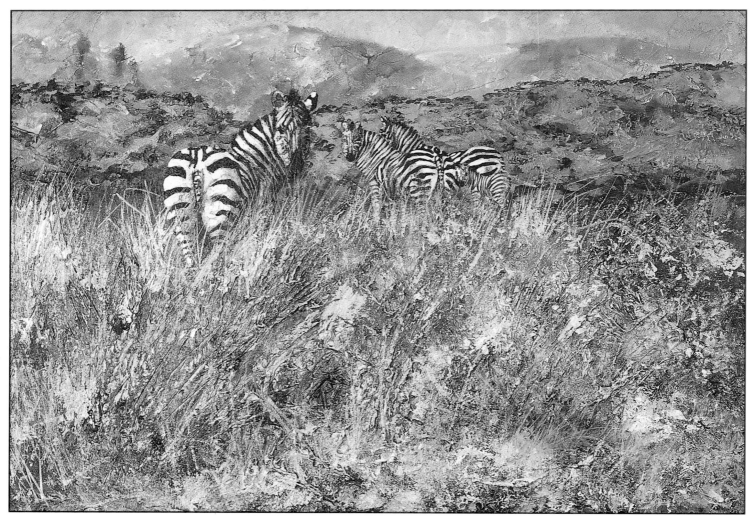

Index

A

acrylics 99-126
 creating texture 115-20
 keeping damp 105
animals
 birds 101
 cats 102-8
 fish 115-20
 zebras 121-6
'Anna's portrait' 54-7

B

backgrounds, portraits 45-6
birds 101
Blended Fibres gel 121
brushes
 cleaning 62
 sponge wash brushes 19
buildings 41, 42-4, 77-82, 95

C

'Campo Santa Maria' 41
candles, resists 19, 29-34
card, painting with 28
cats 102-8
Ceramic Stucco gel 121
children
 portraits 53-8
 portraits from photographs
 59-64
cleaning brushes 62
'Cobb at Lyme Regis' 24-8
colours
 intensity 83
 warm 63
composition
 choosing perspectives 19-22
 self-portraits 45-6, 47
 viewfinders 84, 109-14
Conté pastel pencils 65-70
 sharpening 67
Conté pastel sticks 65-70
crayons, resists 29-34

D

'Davina' 53
dip pens 35, 41-4
dramatic perspectives 19-22

F

faces
 children 53-8, 59-64
 from photographs 59-64
 mixed media 65-70
 self-portraits 45-52
fines lines, and washes 41-4
fish 115-20
flowers 29-34, 35-40, 73-6, 83, 84-8,
 89-94, 109-14
fruit 35-40, 113-14

G

gels, texture 121-6
glazing 119
gloss effects 83
gouache 71-98
 bringing out the whites 95-8
 and gum arabic 83-8
 on tinted paper 89-94
 wash-off techniques 77-82
 and water-soluble pencils 73-6
granulated effects 13
graphite sticks 97
grids, self-portraits 48, 52
gum arabic, gouache and 83-8
Gwynn, Kate, 'View of St Mark's
 Square' 77

H

'Harry's portrait' 58
'Harvest moon' 16-18
heads
 children 53-8, 59-64
 from photographs 59-64
 mixed-media 65-70
 self-portraits 45-52
hedges 17-18
Hemmant, Lynette, 'Campo Santa
 Maria' 41

I

impressionistic effects,
 portraits 53
ink
 pen and wash 35-40, 41-4
 Rapidoliners 35-40
 wash-off techniques 77-82

K

knife-painting 115

L

landscapes
 harvest moons 16-18
 rivers 9-12, 19-22
 seashores 24-8
 snow scenes 101-8
 storm skies 14-15
 sunsets 9-12
 townscapes 41, 42-4, 77-82,
 95-8
lighting, portraits 46
Liquitex 105
 texture gels 121

M

'Michael's self-portrait' 49-52
mirrors, self-portraits 47
mixed-media, portraits 65-70
moons 16-18
Moran, Carolyne, 'Tub of potted
 geraniums' 83

N

Natural Sand gel 121

O

oxgall 14

P

palettes 93
 colour separation 84
papers
 printmaking 9-12
 tinted 9, 89-94
 wash-off techniques 77
pastels, mixed-media portraits
 65-70
pen and wash 35-40, 41-4
 dip 35, 41-4
 Rapidoliners 35-40
pencils
 calligraphic 73
 pastel 65-70
 water-soluble 73-6
perspective, choosing 19-22

pets, cats 102-8
photographs
 portraits from 59-64
 as references 9, 19, 42, 78, 95, 102
portraits
 backgrounds 45-6
 children 53-8
 colour clarity 62
 composition 45-6, 47
 from photographs 59-64
 lighting 46
 mixed-media 65-70
 self-portraits 45-52
 warm colours 63
'Potted red geraniums' 84-8
printmaking paper 9-12

R

'Rainbow trout' 115-20
Rapidoliners 35-40
reference sources 101
 photographs 9, 19, 42, 78, 95, 102
 sketchbooks 16
 sketches 19, 35, 78
reflections, 12, 82, 115
Resin Sand gel 121
resists
 candle, 19, 29-34
 crayon 29-34
riverscapes 9-12, 19-22
'Room with a View' 42-4
Rotring Rapidoliner 35-40

S

self-portraits 45-52

gridding 48, 52
 mirrors 47
shadows, snow scenes 101-8
sketchbooks 16
sketches, 19, 35, 78
skies
 at sunset 9-12
 moons 16-18
 stormy 14-15
Smith, Richard, 'Snipe in Snow' 101
smooth washes 19
'Snipe in Snow' 101
snow scenes 101-8
'Spitz – waiting in the snow' 102-8
sponges
 creating texture with 23-8
 shaping 23
 synthetic 23
still life
 flowers 29-34, 35-40, 73-6, 83, 84-8, 89-94, 109-14
 fruit 35-40, 113-14
'Stormy sky' 14-15
sunsets, skies 9-12

T

texture
 creating 115-20
 gels 121-6
tinted paper, gouache on 89-94
townscapes 41, 42-4, 77-82, 95-8
'Tub of potted geraniums' 83

V

variegated washes 13-18
'View of the Grand Canal, Venice' 78-82
'View of St Mark's Square' 77
viewfinders 84, 109-14

W

warm colours, portraits 63
wash-off techniques 77-82
washes
 delicate 41-4
 mixed-media portraits 65-70
 pens and 35-40, 41-4
 smooth 19
 variegated 13-18
 wet 43
water jars 62
water-proof ink, wash-off techniques 77-82
wax resists
 candles 19, 29-34
 crayons 29-34
wet-in-wet techniques 11
wet washes 43
whites
 bringing out with gouache 95-8
 snow scenes 101-8
Whittlesea, Michael 49
Wiseman, Albany, 'Davina' 53
Worth, Leslie 'Self-Portrait' 45

Z

zebras 121-6
'Zebras on the African plain' 122-6

Acknowledgements

Artists

Richard Allen 7; Roy Hammond 9-12; Richard Allen 13–18; Albany Wiseman 19–22; Stan Smith 23-28,29–34; Audrey Hammond 35–40; Lynette Hemmant 41–44; Leslie Worth 45; Michael Whittlesea 46–52; Albany Wiseman 53; Susan Pontefract 54–58; John Raynes 60–64; Dennis Gilbert 65–70; Kate Gwynn 71; Pippa Howes 73–76; Kate Gwynn 77–82; Caroline Moran 83–88; Stan Smith 89–94; Ian Sidaway 95–98; Richard Smith 99–108; Susan Pontefract 109–114; Richard Smith 115–120; Paul Apps 121–126.

Photographers

Nigel Robertson 23 (r); Mark Gatehouse 29(l); Nigel Robertson 35(l); Mark Gatehouse 42(t); Julian Busselle 47(t); Julian Busselle 49; Nigel Robertson 54(l); Nigel Robertson 58(tl)–59, 65(t), 73(t); Kate Gwynn 78(tr); Nigel Robertson 84(t), 89(tl); Robert Harding Picture Library/Michael Short 95(tr); Richard Smith 102; Julian Busselle 109(t).